Flash Afrique

¡Flash Afrique!

KUNSTHALLE wien

Steidl

Contents

Foreword

The spotlight of "Flash Afrique" turns on a relatively little-known aspect of the art world that deserves to be brought out of the shadow and focused on in close-up. The exhibition deals with West African photography–both the artfully posed studio photos that have become a valuable reservoir of the African identity, and the documentary photos that portray and comment on the madness and existential outpouring in the overcrowded cities. We wanted to investigate the symbols and layers that make these photos into fascinating and complex representations of a social reality which, as the theoretician Olu Oguibe writes, is still perceived as "the other" and can exist only "as an echo, a projection, a suppressed sound".

Africa: Terra incognita? Heart of darkness? Perhaps even the "fashionable continent", as one contemporary belief would have it. A colonial shadow still hangs over this huge landmass, making it difficult to take an objective view. It is a territory of projections and misunderstandings. A theatre of war, but also a debating chamber in which ideologies of different origins struggle for supremacy. "Flash Afrique" does not wish to freeze Africa into "a set of colonies policed by Western desire" (Oguibe) or to reconstruct it from the curator's viewpoint. We relate one of many possible African stories. Or, more precisely, we have developed it together with the artists and curators. As the philosopher Homi K. Babha puts it: "The right to tell stories is more than a linguistic act." This story deals with the relationship between dream and reality, between wishful thinking and the wreckage of reality.

Two threads run through the exhibition: one follows the studio work of photographers like Seydou Keïta (Mali) and Philip Kwame Apagya (Ghana) and focuses on the transition from the craft of portrait photography into the art of creating pictures. The other sweeps the ontological and territorial peripheries of the West African cities of Dakar and Abidjan and, through the works of Bouna Medoune Seye (Senegal) and Dorris Haron Kasco (Côte d'Ivoire), shows the mixture of confusion and enlightenment of social outcasts on the streets. Malick Sidibé (Mali) and Boubacar Touré Mandémory (Senegal) are go-betweens whose photos of wild parties, contemplative street scenes and business life communicate the dream worlds and madness that exist side by side in African cities.

Together with a music programme and symposiums, the exhibition provides an opportunity for examining the complex relationship between Europe and Africa in the 21st century. "Africa," says documenta director Okwui Enwezor, "should not be the psychosexual object of nightmares for Europeans any more."

We would like to thank the numerous collaborators who have helped us to navigate through this difficult aesthetic territory. Simon Njami, editor-in-chief of *Revue Noire* and connoisseur of the African art scene, assisted with the project from the very beginning, directed us again and again to interesting artists and provided a large amount of background information in his extensive discussions with us. André Magnin was generous enough to make available the works of Malick Sidibé and Seydou Keïta and an interview with Keïta. Tobias Wendl provided an invaluable "missing link" between Philip Kwame Apagya and the Kunsthalle, and through his profound knowledge of Ghanaian photography set an intellectual standard that challenged us to ensure that every single detail was in place. We would also like to thank Olu Oguibe, Simon Njami and Koyo Kouoh (Gorée Institute), who wrote articles for the catalogue that define the historical and artistic context of the exhibition, and Ryszard Kapuścińsky for permission to print texts from his book "The Shadow of the Sun". Walter Kirpicsenko has inscribed a narrative structure into his imaginative architecture, which makes it nicely readable even for non-specialists; Ina Ivanceanu and Michael Stadler of the Federation for Cultures in Motion supplied a deeper intellectual and theoretical understanding of the topic at hand by means of an accompanying symposium, and Norbert Ehrlich provided a small but sophisticated musical program that enlivened the exhibition. Finally, thanks to the Kunsthalle Wien staff, in particular Barbara Schröder (assistant curator) and Michael Ziegert (production manager).

Gerald Matt, Thomas Mießgang

Olu Oguibe

The Photographic Experience: Toward an understanding of photography in Africa

Since Nicholas Monti's seminal volume on the subject, there has been a steady interest in the nature and narrative of the photograph in Africa.[1] This interest ranges from shallow and exoticist fascination in search of the extraordinary and picturesque, to serious scholarly engagement with the psychology and politics of the photographic experience. However, there is still far little of the latter in evidence, and a lot remains to be done in order to accumulate a body of knowledge on the history and place of photographic practices in Africa.

To contemplate or be engaged in photography in Africa, at least as has been attempted several times in recent years in exhibitions, brochures and commissioned essays, is to invoke a particular moment in the history of the photograph. Sartre maintained, as did Plato long before and for different reasons, that the image is essentially impoverished, and Roland Barthes postulated that of all images, the photograph is the least endowed, lacking as he argued, the flexibility and versatility of the drawing or painting, for instance, both of which have not only the capability of signification, but also of aesthetic content. Both positions are questionable, especially as we employ the numerous applications and complexities of the photographic image.

However, with the legendary proliferation of the image in recent times, the photograph in particular has suffered even more impoverishment as well as subordination. In the past it was possible to entertain a notion of the fragile integrity of the photograph. This agreeably contentious notion rested on elements such as the indexical quality of the photographic image, the materiality of the photograph as object, and the peculiarity of process in the production of the photographic image. In recent times these elements have all been pried away as new methods and devices of photographic registration, and manipulation becomes commonplace, and equally new devices of critical analysis pry into the structures of photographic signification. So severely has its essence been corroded today that we could almost justifiably declare the death of the photograph.

As its subordination becomes more apparent, it also becomes obvious that gleaning the original potential of the photographic image requires that we shift our attention to a period before its transformation into a mere apparatus of the culture industry. We must focus our attention on that moment when the individual or even the community still had an investment in and a relationship with the photograph. We have to engage a context wherein the photographic moment was still discernible, where the photograph was an event and the image had a resonance unique to it. Even more so, it requires that we employ or place photography within the context of certain traditions of the image not entirely analogous to this moment in the history of the image, especially in the West.

The Photographic Encounter

I recall growing up in West Africa in the nineteen-seventies at a time when photographers were still few and far between except in the cities, and being photographed was still a memorable event. The camera was a special tool identified with a trade, like the men's foot-pedal Singer sewing machine, and not the throwaway plastic toy that it would soon become. It was monumental, too, and with this monumentality came an understandable mythology. It stood like a mysterious mask figure, especially as the photographer buried his head in the black-and-red cotton hood behind the eyes of the camera from whence he occasionally called out his instructions. The great Leica, favored among photographers, with its multiple lenses and levers and shutter-gear, stared at you no differently than the dark, scary mask-heads that my father sculpted for masking societies. And many a child bawled its eyes out as it faced down this mystery figure for a Sunday-morning family photograph.

On those rare occasions we would spend long sessions preparing for a sitting, not counting several days of anxiety and anticipation. My father would rather have the photographer over than sit in a studio setting, for each element in the photograph had an intractable symbolism for him, so he always wanted to have a hand

in the choice of props and background. On arrival of the proprietor of Ebenezer Photos, a rather short and distinguished man who easily took his place in my childhood imagination alongside the school headmaster and figures from history books, would take control like a director his theatrical cast. He would tease, praise, and cajole his sitters, and for us children he would have candies and crackers to rein us in for the moment of glory. As that moment approached he would become grimmer, almost nervous, as he moved around his props and gadgets and put finishing touches to the set. Then he would disappear behind the red and black hood of his Leica like a magician behind the curtains, with a veil of concentration over his face. With the faintest possible gesture of his hands he would motion to be still while, ever so meticulously, he adjusted his mysterious device. Then he would call for a smile, and the huge ball of tungsten would explode. It was all over. Any failures on the part of the sitter: a last second shift, an unanticipated half-yawn, a distracting itch, would be too late to avoid, and too costly. Unlike the press or fashion photographer today who shoots a dozen rolls of film in order to obtain the one perfect portrait shot, Mr. Ebenezer's materials were rare and expensive, and so was his time. Repeats due to errors, therefore, were truly regrettable.

The process of photographic registration itself was equally, and visibly complicated and miraculous, for behind the hooded box camera on its tall tripod you could see the registered image on the wet-plate minutes after the release of the shutter, with the image not only upside down, but also in color, though the ultimate prints from it were inevitably in black and white. Development and printing took a while too, sometimes upwards of a week as the photographer and his apprentices went back to the studio to "wash" or "clean" the photographs. The mechanics of this transformation from life through technology to image on emulsion paper was something only those who joined the trade were privy to, and the mystery of the camera was one that only the few who possessed it could possibly contemplate. However, all these aggregates–tools, posture, preparation, process and result, the moment before the camera–came together to produce what one might call the photographic experience.

Photography as Ritual

The photographic experience was in essence a ritual experience, which, though not enacted with cyclic regularity nevertheless had its discernible structure and pattern. It had an inherent mythology, a ritual procedure, and a central character who was to all intents and purposes a ritual figure inextricably associated with the experience. The engagement was an appointment with history in so far as we recognize history as the calibration of human traces on the surface of time and memory. As ritual, the photographic experience articulated a nexus of myriad associations, characters, and narratives, and provided a moment and context of orchestrated confluence, which was then marked or registered in tangible, memorable form.

The encounter with the camera was not a flippant happenstance, for it was always associated with a significant moment or event, a larger rite of passage, in the individual's life. It was a birth or a death, a wedding or homecoming, an anniversary or graduation, a reunion, and photographers like Mr. Ebenezer and the numerous studio masters that enacted these rituals, were the witnesses. Or else it was an encounter with the law or the State or an institution, which was no less significant, for even the passport photograph for which today we celebrate the uncanny art and vision of Togolese photographer Cornélius Yao Azaglo Augustt, was indexical of significant encounters and rites that were cogent enough to inscribe themselves on the narrative of the individual life: examinations, censuses, criminal apprehensions, passes and pass laws, conscriptions.

Each one of these contexts in turn collated within the other, larger contexts and associations, other narratives, significations, histories, all of which were collapsed in the photographic encounter. For instance, a wedding is of course not simply an exchange of kisses and vows. It is also a confluence of disparate individual narratives, genealogies, preferences, and aspirations, all orchestrated within the frame of complex cultural politics of coercions and compromises. The funeral or family reunion is a staged convergence of contending and often mutually exclusive interests, schemes, suspicions and rivalries. The personal pass is a technology of control that embodies a delicate, routine confrontation between politics and interests, between institutions and the individual, between authority and the personal interest. As ritual the photographic experience congealed, and often

sublimated these potentially exponential webs of intricacies and intrigues, these social entireties, reducing them to a staged encounter with the camera. One could say then that the photographic experience was the stage, what Wole Soyinka would describe as "the ritual arena of confrontation", between human drama and the technology of containment.

Relief, too, was an essential part of this experience, relief at the end of a sitting or session, relief at the conclusion to an often long process of arrangements, negotiations and staging, on the mundane level, but also as the cathartic conclusion of a unique encounter. We may return to this element in due course.

The photograph was the ritual mark, the residual sign and temporal reliquary of this engagement. It therefore had more than tangibility or materiality as an article or object, or as a trace of light on chemically treated paper; it had potency as well because it was a ritual object. And the photographic image was certainly more than a mere replication of the visually apprehensible, or a cheap graphic register for use in an advertisement campaign. Rather, it was a potent embodiment of the essence-reality of its origin.

In many parts of Africa this ritual potency invested the photograph with a certain iconicity. Photographs were treated and handled and employed along specific patterns and in accordance with specific norms. Among the Igbo of West Africa, for instance, the photograph of the deceased would be faced to the wall for a period of time after their death so as to avoid harmful visitationus from their spirit. It was believed that the photograph contains more than a mere image, or rather, that the image is more than a mere semblance or replica of an individual and that it embodies a portion of their spirit. Upon the subject's death such images became even more potent than a death mask, more imbricated with the scent and trace of the deceased. There was of course a psychic dimension to this practice as well. Regular engagement or confrontation with images of the dead not only oscillated the trauma of the bereaved, but held them under a fearful spell because the image in the photograph always has the potential to emerge out of the paper and frame and come at you, to assume a life of its own even as you stare into it. The image in the picture is not inert, only temporarily contained.

Also, among many Igbo, the picture of a deceased young person would be marked or crossed out in red ink, the colour of death, not merely to indicate their demise, but also to cut them off from the rest, and cut them loose for their journey in the after-life. This simple, ritual gesture made possible by the photographic image, served to secure the living as well as ease the burden of transition for the dead.

Among other groups in Africa, or indeed under different circumstances, the reverse of the above was the case, which is to say that the photographic image of the dead was coveted and employed as a tool of psychic convalescence or as a technology of cosmic appeasement. Even as recently as the nineteen-eighties when the pseudo-Marxist, military dictatorship of the Degue ended in Ethiopia, family members who had lost loved ones among the many thousand who "disappeared" under the regime, found photographs of those individuals essential in their process of healing. In Salem Mekuria's documentary, "Yewonze (Deluge)", a bereaved couple goes to the site of a mass grave with a framed photograph of its missing son, as they search for his body among the remains. As the couple watches the exhumations at the edge of the site, the mother breaks into occasional mourning incantations, holding the photograph up to all, and invoking the spirit of her child to avenge itself. The photograph serves two purposes in this unique ritual of closure; it is invoked almost magically in order to facilitate the location of the remains of the deceased. But even more importantly, it is brought in as a "complete", corporeal surrogate of the disintegrated remains of the dead. It is all that remains, and it is whole. It preserves the individual in their wholeness, in their "complete" and recognizable form, in the shape in which they are best remembered. And this "complete" surrogate affords a modicum of succor as the bereaved deal with their loss.

In the Yoruba cult of twins, the photograph again served as surrogate vehicle for the soul and form of the dead, and helped restore a breached wholeness. Usually, before photography, a wooden doll known as an "ibeji" doll would be commissioned to replace and commemorate a dead twin. This doll, which was treated and attended with equal care as the real twin would be, were it alive, helped to provide psychic reassurance to the living twin, and thus prevented it from going in search of its twin. At the same time it obviously served as a device for dealing with trauma, both for the living twin and the bereaved parents, as a tangible reliquary

upon which recollections of the dead could be projected. In the nineteen-sixties and nineteen-seventies, the practice shifted by replacing wooden dolls with photographs of the deceased which were nevertheless derived by doubling the image of the living twin. The result simulated the corporeal presence of the deceased twin and therefore symbolically restored the wholeness or completeness of a twin reality.

About the same time, also, the Yoruba cult of the departed–ako–used photographs of deceased elderly members of the family instead of their statues, as altar-objects around which the commemoration and celebration of such ancestors-become-spirit could be performed. The photographic image was invested with the spirit of the dead, and having interred or anchored that spirit in the image, the bereaved could attend to it and appease it. In effect, photography in this context became part of a technology of cosmic appeasement, a prop in the ritual of ancestral obeisance.

In essence, the photograph as reliquary of both the photographic experience and the social and cultural entirety mentioned above–as ritual object–remained manipulable long after its production, in the interest of individual safety and cosmic harmony. This open-endedness effectively extended the photographic experience and ritual, with the photograph mediating between the living and the dead.

But the aforementioned does not encompass the entire essence of the photographic experience, for no account of photography in Africa would be complete without due consideration of the employment of photography as a technology of the self.

Photography and the Imagined Self

One of my favourite photographs is of a youth holding a book. The subject of the photograph is standing in a clearing, with shrubbery in the background. He is smartly dressed in a rather oversized, white dress shirt fashionably tucked into "windowpane" checkered trousers, and a diagonally striped necktie. He wears an uneasy smile as he hugs the equally oversized book in his left arm. It is a black and white photograph, and on the back of it is a crude, half-legible, oval rubber-stamp with the inscription: "God's Will Photos. Ife Mbaise." In the middle of the stamp there is a some space left for a date, but the dotted line is not filled in. Above the stamp there is a hand-penned inscription in emphatic letters that reads: "Brother/ Oluchukwu Oguibe, University of Nigeria, Nsukka." The inscription is in my father's handwriting, and the precise year of the photograph is 1981. The book in the youth's hand, though its title is not discernible in the photograph except at high magnification, is the Daniel Webster 20th Century American Dictionary. I know these details because I am the youth in the photograph. I was still months away from becoming a freshman at the University of Nigeria.

Although the photograph was taken by the studio master of "God's Will Photos", one of a few that survived from the nineteen-seventies, the set, costume, props and location of the photograph were all determined and chosen by my father. And he was particular about the Daniel Webster Dictionary, which by its title, content, and 3lb weight, signified intellect in no uncertain terms. As indicated, the photograph is the projection of an as yet unfulfilled dream, a state yet to be attained and therefore only resident in the imagination, for although the inscription on the back implies that the subject, namely I, was at the University of Nigeria. At the time the photograph itself was taken, however, I only had a letter of admission to the university, and was yet to register as a student.

On a different trajectory, the photograph codified another projection, for the choice of attire was in no manner typical of my reality as a rural lad who spent as much time on the farm as he did in school. In its careful choice of attire, location and props, the photograph was a makeover the purpose of which was to supplant desire on reality by projecting its subject not as the rural farm boy that he was, but as the university intellectual that he is about to become. The patron in this instance–namely my father–was anxious to realize a state of the imagination by staging it through the preemptive power of the photographic encounter. Behind this anxiousness, however, lay a secret. Having watched his own youthful aspirations for intellectual accomplishment thwarted and aborted by war and personal misfortune, he had projected those onto his son from the moment of the latter's birth. The photographic experience in this case, then, was a ritual drama of both expi-

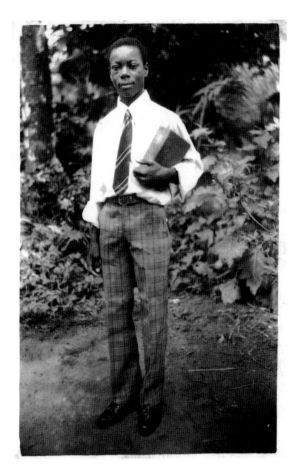

Young man with a book, 1981, God's Will Photos, Ife Mbaise, front and back

ation (of the past) and projective transfiguration (of the future). Part of this ritual was essentially chthonic in that it did not differ from the magical employment of the image in antiquity when the cave dweller transfixed his game through drawing, before he stepped out on a hunt. Photography was the device for this transfixion, and the photograph a graphic register of the imagined self, albeit projected on a subject other than the self.

In Athol Fugard and John Kani's play, "Sizwe Bansi is Dead", a redoubtable drama of expiation and transfiguration, the protagonist spends a considerable portion of the play in a photographer's studio where he sits for a photograph of his new self, which will accompany a letter to his wife and family. A migrant worker from rural South Africa, he had already literally transfigured himself by acquiring the work pass and identity of a stray, homicide victim, the true Sizwe Bansi, and with this and the collusion of a friend had found himself a job in the mines. Life working in the mines is, of course, not at all glamorous, but he must not present that image to his family. Like every other "mine boy" who had to reassure his family back in the countryside that he had made progress in the city, the photographer's studio was the chamber of dreams, the laboratory for ritual alchemy, where reinventions and transfigurations were accomplished and the grimy mine-boy, for a brief intermission, assumed whatever guise his imagination and temperament allowed, and registered the same for himself, his family, and posterity.

Photography as ritual self-imagining is of course a universal phenomenon that goes back to the early days of the art. We find it in Mehmet's court in Egypt as early as 1839, shortly after the advent of photography in Europe, and in the royal court of Abyssinia a few years later. In the late 19th century, it was already popular in South Africa, as Zwelethu Mthetwa has noted in his brief study of family photo albums among black South Africans of the period. In West Africa renowned studios such as those of Walvin Holm and the Da Costa brothers thrived in Accra, Freetown and Lagos, and by the turn of the century, popular photo studios had sprung up in most major cities across the rest of the continent. This ritual of self-imagining would become the singular, most important sustaining framework for photography in Africa, especially studio photography, fuelling the practice and careers of innumerable, great studio masters–from those who would become well-known internationally, like Seydou Keïta, to the likes of Mr. Ebenezer, whose fame resided within their own localities. Even non-sedentary, urban practitioners like Malick Sidibé presented their subjects with opportunities to photograph and freeze their likeness in a particular, preferred state of their own design, which became the generic, perennial register of their identity. Through photography the individual could now intervene in the natural, cosmic process to ensure his own longevity. He was enabled to impinge on the territories of divine exclusivity to undermine and reconfigure the conditions of his or her mortality.

In earlier times this transfiguration was left in the hands of cosmic forces, and was made possible only through reincarnation. The individual defined and designed his or her preferred self in the imagination and expressed it through utterance, but the implementation was at the mercy of the gods who either granted that desire, or overruled it at the moment of reincarnation. But with photography the tools of self-reconfiguration were made available in the quotidian.

What is most fascinating about this, however, is not so much the employment of photography as a technology of the self–as a tool for self transfiguration and transfixion–but that it took place within many African cultures where any other record of the human visage was a risk and therefore ominously avoided. The Igbo, for instance, believed that artistic replication of the human countenance was only safe if the face in the image belonged to no-one in particular. Otherwise to reproduce the likeness of a specific individual was to invoke imminent death on that individual. Among the Yoruba mimetic representation of specific individuals was left to royalty or outsiders, and seldom was the image or likeness of a particular individual contemplated, at least not until the nineteen-fifties.

The question then arises: How did these cultures come to embrace a ritual whose sole purpose, it seems, was to reproduce the likeness of the individual, to do the intolerable and unacceptable? How and why did they succumb to a practice the principal condition of which was that the individual submit himself or herself to a ritual of self-sacrifice? One immediate answer lies in the fundamental shift in the eschatology of many African cultures, which colonialism and Christianity enabled. Whereas in the original cosmogonies of these cultures

immortality was an integral part of the eschatology, something for which human intervention was unnecessary, except in determining the nature of that immortality through the moral choices each individual made in life, with Christianity this guarantee was unhinged and withdrawn as Christian eschatology attenuated the individual's chance of existence on earth. In other words, whereas in the past it was accepted that the individual could experience life in the earthly realm countless times, with Christianity there was the promise of only one life on earth, and then Judgment.

Because real, earthly immortality was no longer possible, the quest for symbolic, earthly immortality became inevitable. As a species humans have a chthonic, psychic investment in immortality because it provides them with a handle on the mystery of death. When this investment is threatened or undermined, or indeed invalidated as Christianity almost does, then they are compelled to seek restitution or else be set adrift on a sea of psychic crisis. Hence the gravity and catharsis of the photographic experience which resides in a renewed confidence in the possibility of immortality. Again, in "The Ritual Archetype" Wole Soyinka writes about "some act essential for prolonging life".[2] After the invalidation of the promise of reincarnation, photography as a technology of the self, a device for self-reinvention and perpetuation, became one of these acts "essential for prolonging life". The photograph became a site of longevity.

Also, the subtle iconoclasm of Christianity undermined the image in many African societies, on the one hand dissipating the dread of images made in the likeness of one's living self, while on the other hand allowing such images as sites of self-perpetuation. It effectively destabilized the meaning of perpetuation, reducing it from a cosmic imperative to a secular preoccupation fully in the individual hand. This demythologisation would have a lasting affect not only on the ritual import of image-making, but photography in particular.

The Lived Experience

Again, the foregoing fails to encompass all that might be associated with photography in Africa. For instance it does not cover certain patterns or paradigms of practice that you might find in this book, such as voyeurism, photography of the picturesque, or the social realist documentary. Today photography in Africa has taken many forms, as in other parts of the world, and may be spotted in a subordinate role in advertising just as it may be found in revivalist studio settings. Yet none of these forms of photography is so central or crucial to survival—as has been argued here—than that which collated a people's entire world and preserved it in a portable sign, a ritual object of modest physical dimensions that once was treated with iconic gravity but may be regarded today with post-human levity but still, in the end, contained the fustian complexity of a memorable experience.

To grasp the gravity and palpability of the photographic experience is to begin to understand the uniqueness of photography in Africa over the period of more than a century, during which the finest photography from the continent was produced. It also helps us to understand that though the science of photography is universal, photography itself is nevertheless culture-specific, defined and supported by varying cosmologies and the different technologies of survival that they occasion or demand.

Notes

1 For further reading see: Olu Oguibe, "Photography and the Substance of the Image", in: Clare Bell, Okwui Enwezor et al., *In/sight: African Photographers, 1940 to the Present*, New York 1996 and Nicholas Monti (ed.), *Africa Then: Photograph, 1840-1981*, New York 1987
2 Wole Soyinka, "The Ritual Archetype", in: *Myth, Literature and the African World*, Cambridge 1976

Thomas Mießgang

Directors, flaneurs, bricoleurs: Studio photographers in West Africa

The Senegalese Ibrahima Dieng needs a photo for an ID card but wants to spend as little money on it as possible. He goes to five or six studios but they are all too expensive for him, so he finally settles for Atelier Ambroise, which charges only a modest amount. But after he has posed under the lights and the photos have been taken, things start to take a bad turn. When he goes to collect his photo the next day, he only finds an apprentice in the studio who doesn't know where his master is and refuses to hand over the photo. Instead, he accuses Ibrahima of bringing bad luck, saying that ever since he came to the studio, the camera didn't work any more and the portrait was in any case unusable. The situation begins to get out of hand: the customer feels cheated and wants his money back; the apprentice digs his heels in and refuses. Matters deteriorate and the two come to blows.

And then, after Ibrahima has wrecked the studio and got a bloody nose, Ambroise the photographer appears like a *deus ex machina*. Far from defusing the situation, however, he escalates it even further: neck bulging and eyes blood shot, he flies into a rage of biblical proportions, insulting Ibrahima and managing, in the process, to get the onlookers who have gathered to be on his side. Dieng, who still believes that he is in the right, finally has to admit that he cannot win against the stubborn man with the camera and departs without his photo or his money.

This episode from the reputed novel "The Money Order" by Senegalese author and film-maker Ousmane Sembéne says something of the power and social status of studio photographers in West Africa, particularly in the 1950s and 1960s. If, like Jean-François Werner and Erika Nimis, we think of the photographer as "guardian of the community's visual memory"[1], portrait specialists, who for a long time had an almost hegemonial monopoly on the mechanical reproduction of images, may be regarded as a modern and visual version of the *griot* singers. Just as the latter sang the praises of princes and successful businessmen, photographers took the yearnings, dreams and desires for admiration of its socially segmented clientele and turned them into attractive pictures. Their studios were dream factories, launching pads for self-styling, settings in which to symbolically transcend the all-pervading poverty. While the *griots* for centuries had low social status, photographers appeared at a time when urban agglomerations of late and postcolonial Africa were already beginning to undermine traditional hierarchies. Their domain was the city and the object of their visual adoration was any person with the money to pay for a photo. They were the mediators of a modern world that had gradually created new taxonomies, values and desires. And they were able to establish their profession outside of traditional structures and hierarchies. The studio rapidly became a dream factory and the photographer the director of the clients' desire to portray themselves in ideal terms.

Domination over people's dreams creates power. On the wings of these dreams many photographers flew high into the social stratosphere: Abdouhramane Sakaly from Bamako in Mali photographed banquets, soirées in large hotels and even politicians, and in doing so acquired the trappings of a playboy with his elegant suits and snazzy limousines. His friend and rival Seydou Keïta, whose studio was situated near the large Soudan cinema, exploited the iconography and black-and-white *mise-en-scène* of the American films that were shown there. "The tough-guy looks and gangster-like demeanour found in his photos seem straight out of a B-movie still," writes cinema and photography theoretician Manthia Diawara.[2] With his pictures, which often bordered intuitively on the surreal, dissolving the outlines of the body into a blurred chiaroscuro of textile patterns and the wavy lines of studio brochures, Keïta created a picture of contemporary attitudes in Bamako. "Having one's portrait taken by Keïta signified one's cosmopolitanism."[3]

Malick Sidibé, 13 years Keïta's junior, whose most important work dates from the 1960s when Keïta had already abandoned his studio to work for the Sûreté Nationale, was a representative of the transition to freer and more spontaneous forms of photography. Many of his works are classic studio portraits, but for others he mingled with the *jeunesse* of Mali, photographed groups of young people amusing themselves on the banks

of the Niger and took pictures of wild parties in which ecstatic dance movements were frozen into grotesque body sculptures.

Bamako was one of the centres of studio photography. But in other West African cities the man behind the viewfinder became a seeker and director of existential transgressions as well. In Ghana there were Francis K. Honny and James K. Bruce-Vanderpuye, who was one of the first Africans to develop documentary photography away from the studio. In Korhogo, in the north of Côte d'Ivoire, the recently deceased Cornélius Yao Azaglo Augustt had his "Studio du Nord", and in Senegal there were Meissa Gaye, and Mama and Salla Casset, immortalised in Ousmane Sembéne's novel "The Money Order" mentioned earlier.

How is it possible to describe the essence and aura of photo studios, which were often little more than shacks but nevertheless represented "little dream factories in the middle of corrugated iron shanties and crumbling houses"?[4] They were generally located where people congregated: near markets, taxi or bus stations or, as was the case with Seydou Keïta in Bamako, next to the railway station. They were glamorous and diverting places in cities almost completely lacking a cultural infrastructure. Social facilities that served to beautify and symbolically transform life, but also meeting places where groups could chat and gossip casually in an ambivalent atmosphere that combined discipline with the subversion of social standards. The pictures created in the studios offered the subjects an opportunity to translate the visual symbols of power into a micropolitical statement about themselves, but at the same time to flout prevailing codes through unorthodox clothing, eccentric poses or bizarre accessories. The way in which people joked and chatted and experimented with individual poses and group arrangements is marvellously captured in the documentary video about Cornélius A. Augustt by Dorris Haron Kasco, which can be seen in the "Flash Afrique" exhibition. Looking directly at the moving pictures, one can see that the studio in urban Africa was a meeting point of public and private spheres: an Aladdin's cave of secret desires negotiated with the photographer, in much the same way as the Catholic confessional, to develop ultimately into a permanent artefact, and at the same time an *agora* for jocular or even smutty exchanges. The innermost and most public aspects of a person collided and created friction, sometimes with an erotic note as well. The nearest Western equivalent to the African photo studio is perhaps a hairdresser's salon or gym, where a similar mixture of concentration and idle chatter, the sweat and perfume of dissipation hangs in the air.

Photos as an ontological tattoo, a plaster cast of an idealised ego, were circulated in a milieu that was unknown or had ceased to exist in Europe: on a continent in which illiteracy in most countries was still well over 50 per cent, they became conveyors of messages and totems, objects for exchanging and symbolic mementos. "The pictures exist in a completely different narrative context," Okwui Enwezor once said in an interview.[5] "People wouldn't make [...] 40 copies of their photos and send them to their 40 closest friends if they didn't want to be remembered. [...] They represent fantasy and wishful thinking, the reproduction of themselves, even in transient form. This fiction does not capture reality, but expresses a condensed version of it. The public must understand this fantasy as an interaction of words and pictures but also of narrative and discourse, which provides a framework within which important messages can be sent."

The golden era of West African studio photography is now history. After colour photography arrived on the continent and the unwieldy bellows cameras were replaced by lightweight compact appliances, a new type of mobile photographer appeared, wandering through the streets of the city, visiting villages and picking up customers on the way.

This put an end to the limited setting of the studio which, while allowing some scope for variety, nevertheless always had the fixed studio situation as its point of reference. Mobile photography marked the start of an African version of the "anything goes" mentality: subjects who had previously allowed themselves to be directed by the photographer now had a greater say in when, where and how they were photographed. This resulted in greater variety, but it also meant that the style and aesthetic preliminaries were less and less focused. For better or worse, the erosion of the ritual studio *mise-en-scène* also saw the disappearance of a strict taboo that studio photographers had insisted on, namely a refusal to take erotic or pornographic photographs.

Although colour photography was instrumental in the downfall of the studios because of the increased

expense involved, it also contributed paradoxically to their renaissance. One of the main reasons for the dwindling attractiveness of traditional studio photos was that settings and accessories used as an iconographic background were seen as old-fashioned. Many of these elements were simply copied from models developed for European studio photography, which were now long obsolete. At a time when the fundamental legitimacy of colonialism was being questioned and the drive for independence was in full swing, there was a desire to throw out handed-down colonial-style photographic canons, and to invent a new symbolic counter-presence and visual hypostasis. In Ghana and in Kenya with the Likoni Ferry photographers in particular, the studio photograph was revived, but in a much more up-to-date atelier with colour settings using symbols that could be exploited to convey a contemporary feel: gone were the plain curtains, columns and stools, to be replaced by streetlights, as a synechdotal reference to the electrified city, overhead transmission masts, petrol stations, airports, ocean-going ships and computer workstations.

These settings, usually created by highly specialised artists, were in a naive realistic style with no attempt to mimic the objects perfectly in the way that Western photo-realism did. "They remain constructs that play on and even evoke this artificiality," wrote Tobias Wendl and Margit Prussat, "navigating between reality and illusion."[6]

The great master of the renaissance of colour studio photography is Philip Kwame Apagya, who runs a studio in the town of Shama in Ghana. One of the most popular of his illusions is the "Room Divider", a wall cupboard that separates the living area from the sleeping area in African houses. Apagya's colourful room dividers are packed with the desirable accoutrements of a consumer society: television, VCR, refrigerator, stacks of CDs, high-proof alcohol-trappings of an exuberant lifestyle that must remain a dream for many Ghanaians and that are given symbolic value through their obvious artificiality. Apagya's sense of the modern oscillates between hyperrealism and surrealism, in strange contrast to the aesthetic terms of reference of the (post) modern Western perception. Internet cafés, Western fashion and a hybrid pop culture are booming in West African cities and photographs could therefore represent these dreams with a much higher degree of realism. But Apagya and his colleagues prefer the painted backdrops, which mark the ontological boundary between the physical and the metaphysical, covering these items with a thin coat of paint to mask their absence without attempting to disguise the fact that there is in fact nothing behind the illusion.

This synchronicity of the non-synchronous could well be the reason that these pictures are so attractive to Western observers, always thirsty for unaccustomed visual stimuli: the intrusion of the archaic in a world in the thrall of digitalisation, the cool ecstasy of a parallel, symbolically frozen universe where wish fulfilment runs amok.

Like Philip Kwame Apagya, older colleagues Malick Sidibé and Seydou Keïta also enjoyed a new lease of life, long after they had ceased to be active thanks to the recontextualisation of their work through exhibitions in Paris or New York.

The transformation of photos that had originally been intended as crafted items made for a very specific purpose into works of art, naturally causes certain problems in terms of observers' expectations. Torn out of context and thrust into a world of contemporary photography produced by other cultures, the attraction of the pictures is often reduced to the perception of surface textures seen within the framework of the categorical imperative of Western 20th century modern art. To penetrate more deeply into the material, however, a detailed consideration of the socio-psychological, ritual and political framework in which these pictures were set free into the world is needed. West African studio photographs are complex fabrics that contain numerous coded messages, often directly woven into the textiles worn by the "actors"–in the case of Ghanaian Adinkra fabrics, for example, where every pattern has a linguistic equivalent. Kerstin Pinther speaks in this context of a "rhetorical culture of allegory, of saying things differently."[7] Messages are also conveyed by the position of the subject and the gesticulative arrangements (see interview with Dorris Haron Kasco, who interprets a photo of three women as a message of condolence). Pictures of this type often take the place of letters.

However arcane these interpretations might be, African studio photographs can still have a valid first-degree impact. A well-known photo by Seydou Keïta, for example, shows two women whose bodies face each

other while their heads are turned to look at the camera. They are both wearing ankle-length robes and head-scarves with a bird–possibly a flamingo–pattern. The background is one of Keïta's standard motifs: wallpaper with a leaf pattern. As there is no emphasis in the lighting, the setting becomes almost two-dimensional and the women appear to blend into the background. Because of the superficial similarity between the studio backdrop and the fabric pattern, it becomes even more difficult to distinguish the subjects: the body outlines become blurred, the clothes and wallpaper merge to form a macro-ornament. As both women are dressed in the same way and are standing close together, their bodies also seem to fuse into one another. The arrangement is strangely reminiscent of Siamese twins, emphasised by the fact that the hands of the two women are touching while their faces have a mask-like sternness. The body and its double, the mirror stage as formative of the function of the I, the ontological ecstasy of multiplicities–Keïta's picture invites wild speculation and flights of fancy into conceptual areas with porous limits, where ambiguities cannot be domesticated.

The younger Malick Sidibé is less interested in a semantic imbroglio of this type than in sheer presence, be it in the groups of young people arranged in a *tableau vivant* on the banks of the Niger or the strolling nocturnal passers-by in Bamako, proudly holding album covers (many of which are American) towards the camera like amulets, or caught in a dancing frenzy. Sidibé is a chronicler of the present in a universalistic sense: his protagonists are mostly dressed in the Western fashions of the 1960s and 1970s; "Party Animals" and "Fashion Victims", representatives of the global youth culture who happen to be in Africa, or so it seems. Many of these works thus have more in common with the iconography of the worldwide teenage rebellion than with Keïta's cryptic visual messages. Take away the captions and they could have been shot in Harlem or the Bronx.

Philip Kwame Apagya, descendant of the studio tradition, presents a compromise between these two positions (depicted here *in extremis* and perhaps not so polarised if the entire bodies of work were to be considered). He mixes archaic features and modern symbols to produce a virtual reality without geographical or temporal limits: an unstable iconosphere subject to arbitrary interpretation whose shifting symbolic aggregations are triggered by the polymorphous character of the combined visual modules.

West African studio photographs thus offer a user interface, a semantically rough surface texture that can become part of the ritual picture-swapping in an image-filled world, but they also contain a plethora of distinctive aesthetic and communication strategies whose complex meanings can be understood only through a process of deciphering using psychoanalytical, sociological and ethnographic methods.

Of particular interest in this context is a text by the German Janheinz Jahn written in 1960. He describes how "terribly bored" he was when he first looked at photo albums of African families: "Lots of pictures in which people pose alone or in groups, stiff and lifeless in their best clothes, all looking blankly at the camera, standing or sitting facing the viewer, larger groups arranged symmetrically, hardly anyone smiling."[9] But he soon realised that this style was not because of an inability to do otherwise, but was intentional. These were not snapshots, but conscious representations: "Individuality is suppressed, references to the present are cut out. The subjects show their 'Muntu face', that eternal deathless physiognomy that they will pass on to their descendants even after they are dead."[10] Jahn compares looking at the photos with learning a language: the more precisely the pictures are calibrated, the clearer the connection between the subjects, family hierarchies and micro-deviations under the mask of collectivity. What appears boring at first becomes a microscopic study of social conditions at a given time: "I learnt to read the pictures."[11]

Western observers must pass through this cognitive self-education if they wish to penetrate further than the superficial aspect.

Studio photos were not meant to be works of art, but everyday artefacts. Thus they cannot, in any way, be thought of as epic heroic tales of Africa's emerging independence, but rather as a patchwork of contradictory stories. The pictures were used for a number of purposes. Women in particular liked to register and perpetuate their wardrobe in symbolic form–"the album as a clothing diary in visual form" (Kerstin Pinther). They were also used as a material substrate for a dead person, for magic or representation, the degree of abstraction in the subject's features correlating with the social status.

One social function that makes (amateur) photography attractive throughout the world did not until recently have any place in Africa: the snapshot as a means of capturing and freeze-framing a moment from the exis-

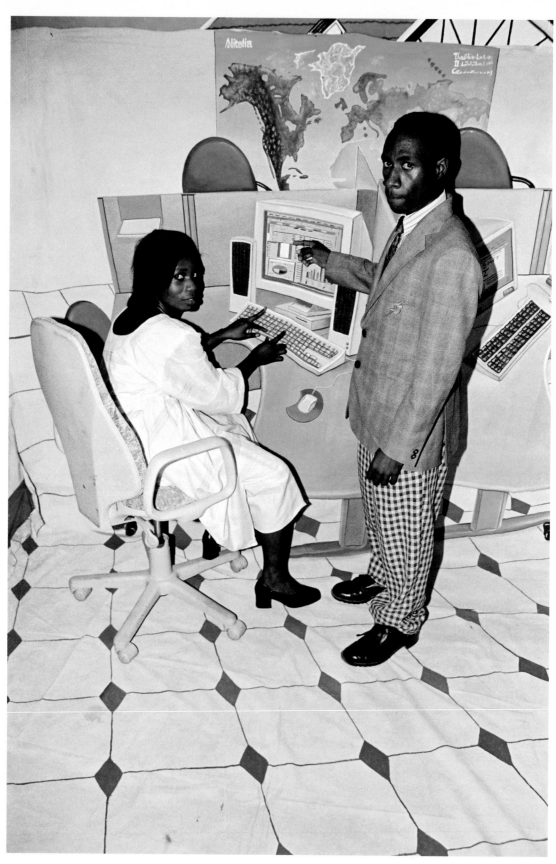

Philip Kwame Apagya, Booming Internet, 2000

tential continuum, of slowing down the dynamism of ontological succession in a series of stills, of fixing an "object" at the moment of its most self-seeking vitality.

Since African studio photography is almost always posed and stylised, the aim is not to produce an authentic and spontaneous picture, but to plastify the corners and edges of a subject engraved in the physiognomy, "dividuation" of the individual, so to speak. Retouching is therefore very popular, be it with a graphite pencil or through technical manipulation. The modifications can range from lightening the skin and adding rolls of fat to the neck as a sign of prosperity, to colouring black and white photos with oil paints or changing the clothing. The photographs become veritable palimpsests, with each modification revealing new interpretations of the source material. Observers schooled in Western pop symbolism might see similarities with the remix and recycling strategies of contemporary DJ techniques. In an era of endless permutability, these pictures have slipped into a time slot somewhere after the invention of reproduction technology but before the advent of the photoshop.

The idiosyncrasies of the African photo world can also be seen in the splitting up of a photo protagonist into several entities through the use of montage; visual cloning that overcomes existential limitations: heads are duplicated and distributed over the entire picture. Sometimes the duplications are identical, other times they differ–with or without a beard, for example–to represent different draft versions leading to the final projection that is discussed within the picture itself. This tendency to diffuse the individual bears a relationship to the artistic movement initiated by Warhol that takes seriality as its theme, while offering a criticism of consumerism and culture at the same time: an African reflection of global perceptual dissonance. It is more likely, however, that the retouching, duplication, hyper-individualisation and group arrangements on studio photos have something to do with Africa's relationship to the former colonial powers. The dialogue between a white Western establishment and African artists, writes Olu Oguibe, remains a simulacrum today: "The Other can exist only as a projection, an echo [...] It speaks to a discourse of power and confinement in current Western appreciation of modern African art; a discourse of speech and regulation of utterance, which, by denying African artists the right to language and self-articulation, incarcerates them in the policed colonies of Western desire."[12]

In these circumstances, the interpretations embedded symbolically in studio photographs may be seen, as V .Y. Mudimbe puts it, as the *reprendre* or recuperation of a genuine visual repertoire.

The visual rhythms in the fabric patterns that sometimes appear to emanate in massive waves from the wearer are thus reminiscent of the endless flow of African Highlife, Wassoulou or Mbalax music. And in Malick Sidibé's dance, the obsessive cult of animistic religions seems to have found a new secular vehicle.

But this *reprendre* did not take place in a politically stable era with clear domination (and exploitation) hierarchies, but at a time in which African states were questioning the legitimacy of colonialism and demanding independence.

The visual symbols and arrangements in the micropolitical environment of portrait and group photography are a distant reaction to the continental *rite de passage* to a new African self-awareness. There are two striking and diametrically opposed stylisations: individuality emphasised by carefully chosen accessories, like the young man photographed by Keïta, who transcends the stiff official exterior through the addition of a rose; and the new choreography in the photographs of groups, whether they be symmetrically arranged, connected by a common textile signifier or casually lined up like Malick Sidibé's youths on the banks of the Niger. These visual images are in fact two sides of the same coin: at a time when the continent, split between Leopold Senghor's Négritude movement and Kwame Nkrumah's Pan-Africanism, sought political independence and also a way of inaugurating a new African awareness, the aim was to break free from traditional stereotypes, Oguibe's echoes and projections, that emphasised the reduced and domesticated status. By showing his personal idiosyncrasies, the individual became more distinctive and gained a voice for himself in the prison of Western standards. The erosion of certainties, even uncomfortable ones, also gives rise to a desire to undermine the chains of command established through colonial domination, to dismantle production units assembled for their economic efficiency and to replace them by new groupings. The studio portraits thus provide a dialectic signification of the protest of the individual and the need for the reorganisation of society.

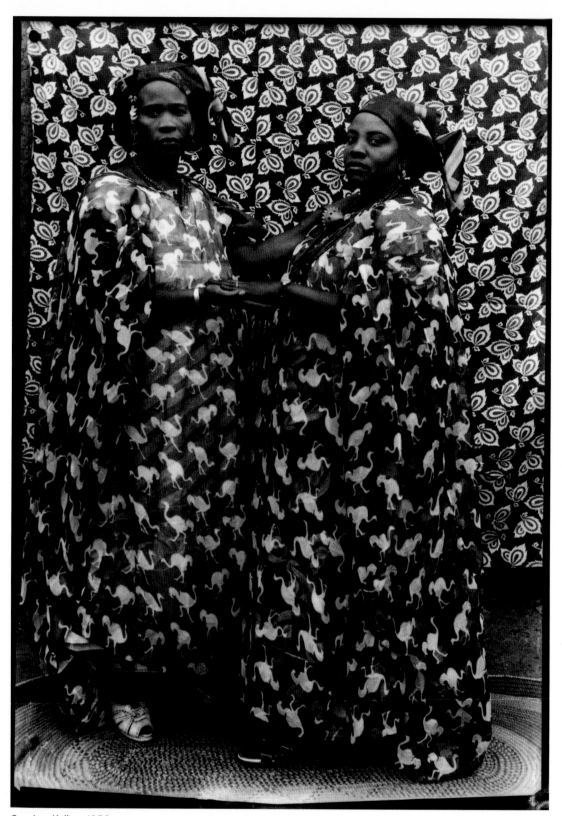

Seydou Keïta, 1958

Blurred significance, shifting visual parameters, remixed traditions: in the polymorphism of the visual and contextual "instigations", West African studio photography is not only the visual memory of the community, but also a sort of energy that anticipates the hybrid art forms that currently dominate countries like Senegal, Mali or Ghana, be it the meta-fashions of Oumou Sy, the ethnicised funk music of Oumou Sangaré with its characteristic harp-like *kamelangoni* backing, or the low-budget massacre of Western pulp stereotypes provided by Ghanaian horror videos.

"The artists of the present generation," writes V. Y. Mudimbe, "are the children of two traditions, two worlds, both of which they challenge, merging mechanics and masks, machines and the memories of gods."[13] And the studio photographers were their fathers and grandfathers: "Picture is a silent talker," Philip Kwame Apagya once said, "but if you know how to look at a picture, you will always see, what is hidden deep inside."[14]

I would like to thank Olu Oguibe and Okwui Enwezor, Tobias Wendl, Heike Behrend, Kerstin Pinther and Jean-François Werner, whose work provided material and ideas that enabled me to put together some fragmentary thoughts, information about the complex subject of studio photography, its links with both modern and traditional art, its "talking" textiles, ritual practices and hyperstylised idea of modern Africa.

Notes

1 Jean-François Werner / Erika Nimis, "Zur Geschichte der Fotografie im frankophonen Westafrika", in: Tobias Wendl / Heike Behrend (ed.), *Snap me one! Studiofotografen in Afrika*, München, London and New York 1998, p. 20

2 Manthia Diawara, "Talk of the town: Seydou Keïta", in: *Reading the Contemporary African Art from Theory to the Marketplace*, London 1999, p. 236

3 *Diawara,* ibid., p. 236

4 Tobias Wendl / Margrit Prussat, "Oberservers are worried", in: *Snap me one!*, p. 29

5 Michael Thoss / Okwui Enwezor, "Spotted Vision. Fotografische Fantasien und Visionen", in: *Porträt Afrika*, Berlin 2000, p. 19

6 Tobias Wendl / Margrit Prussat, "Oberservers are worried", in: *Snap me one!*, p. 34

7 Kerstin Pinther, "Wenn die Ehe eine Erdnuß wäre ...", in: *Snap me one!*, p. 37

8 Janheinz Jahn, in: *Durch afrikanische Türen, Erlebnisse und Begegnungen in Westafrika,* Düsseldorf and Cologne 1960, p. 202

9 ibid., p. 203

10 op. cit., p. 203

11 Olu Oguibe, "Art, Identity, Boundaries: Postmodernism and Contemporary African Art", in: *Reading the Contemporary*, p. 19

12 V. Y. Mudimbe, "Reprendre, Enunciations and Strategies in Contemporary African Arts", in: *Reading the Contemporary*, p. 39

13 Tobias Wendl, "Philip Kwame Apagya", in: *Snap me one!*, p. 52

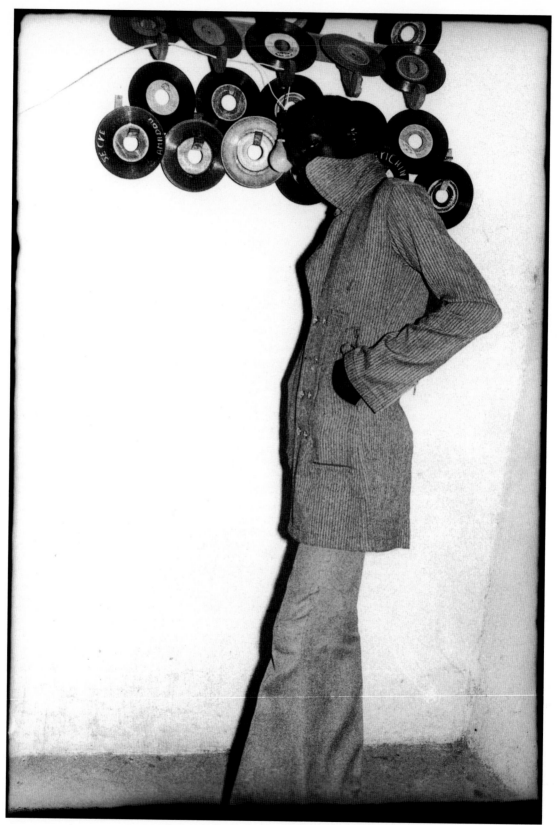

Malick Sidibé, Je suis fou de disques, 1973

Simon Njami
The reign of the intractable

> The insane are outside the bounds of reason and the norms of society. According to the Gospel, human wisdom is madness in the eye's of God, and divine wisdom is madness in the eyes of men. The term madness stands for transcendence.[1]

The urban environment is a neurotic and hostile space. Its concentration, density and atmosphere destabilise human beings, these hunter gatherers who find it difficult to keep up in the frenetic pace of the industrial era. This environment also secretes both viruses and antibodies. It is the epitome of an anti-human and totalitarian space, a combined symbol of Hell and Paradise. In Africa the urban environment is a relatively recent phenomenon. This evolution, in the chronological sense of the term, which reached its peak in Europe in the technological achievements of the Industrial Revolution, did not start in Africa until the mid-19th century with the establishment of the administrative structures of colonialism. Like an earthquake whose after-effects are still being felt, the far-reaching changes that this revolution introduced to Africa have created a new physical and human geography.

The first thing a person getting lost in an African city has to do is to redefine his very concept of a city. Apart from the concentration, chaos and speed that all cities have in common, the Guinean writer Tierno Monénembo's[2] description of Abidjan seems eminently appropriate: "There is no sense of city here. New districts blossom, flower and wither. And then they sprout up elsewhere as if their seeds have been carried by the wind." What is this "sense of city", and does the city have any sense? Do the spiral layout of Paris's arrondissements or New York's grid system give a city a sense? I believe that the "sense" of a city in Africa cannot be found in geometry or any conventional, verifiable logic or urban planning. The city here is not a physical entity with street names and signs, but an intangible phenomenon. African cities are part of the same elementary animistic intuition that governs African thought, both Christian and Moslem. This animism inevitably dooms to failure any attempt to fix the notion of a city. The buildings become trees, the streets are fields, and the cars take on the appearance of wild animals. The metaphor is a little exaggerated, perhaps, but it is important to understand that in Africa a city is not a city. Cinema, which is incapable of conceiving this idea in its totality, provides a good example of the difficulty in trying to find a material equivalent for this metaphor.

Of course, 12th-century Africa with its great empires, before the arrival of Europeans, had its *cités* and major centres. But I use the word *cité* rather than city, because the latter and the concept of urbanism are relatively recent phenomena, as I have already pointed out. It is based on a model that pits social organisation, in the Platonic sense, against administrative organisation: human self-organisation against technocratic administration. The medieval *cités* of Africa had a clan structure, not unlike the extended family, whose physical and political significance depended on the power and wealth of the ruling family. Freud's evocation of the way in which the first Europeans perceived the African continent highlights these two different concepts of the world: "But a factor of this kind hostile to civilization must already have been at work in the victory of Christendom over the heathen religions. For it was very closely related to the low estimation put upon earthly life by the Christian doctrine. The last but one of these occasions was when the progress of voyages of discovery led to contact with primitive peoples and races. In consequence of insufficient observation and a mistaken view of their manners and customs, they appeared to Europeans to be leading a simple, happy life with few wants, a life such as was unattainable by their visitors with their superior civilization."[3]

There is thus a fundamental misunderstanding at the base of the African city: a poetic conception of the world versus the inflexibility of all-conquering reason. The clash between these two philosophies was destined to end in chaos. The African city thus had no alternative but to survive from day to day–and to rejoice in wonder every morning to find itself still in existence. In the streets of Bamako, in the area round the railway station, the municipal authorities regularly dismantle the stands overflowing from the market onto the

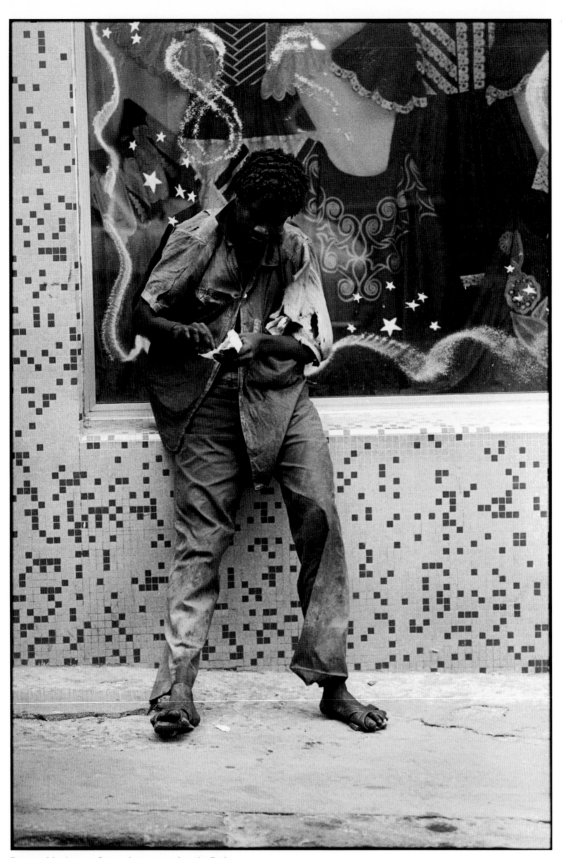

Bouna Medoune Seye, Les trottoirs de Dakar

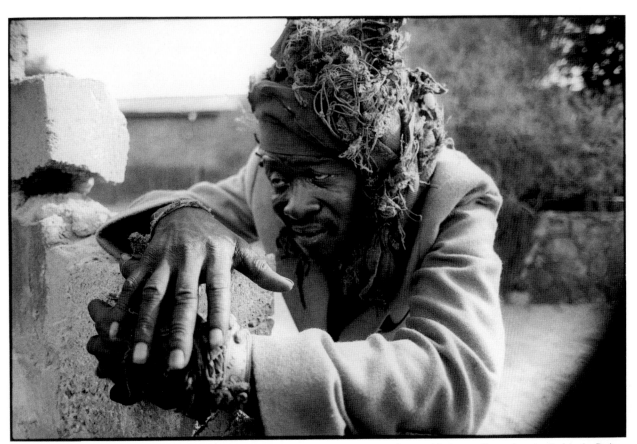

Bouna Medoune Seye, Les trottoirs de Dakar

streets and blocking traffic. And every time, the traders come back like stubborn phoenixes as if to say that the community's problems are not theirs. The city develops its own momentum. It is a forceps-delivered avatar that has achieved an independent existence-one that it apparently owes to no-one except to itself. It is an insatiable stomach that absorbs everything without any recognisable order or logic except for the logic of life. In those parts of the world where the future has no value and only the present counts, it is hardly surprising that plans are worthless. Things are defined by their use. And whatever energy the State might invest in it, the African city develops only through use. Whether it is like Rastignac's quest or whether the city serves as the opposite pole to the simple, well-organised and socially balanced life in the country, its fascination is probably greater than anywhere else in the world. "Aunt Akissi is right: 'this city is a disgrace', astounding and necessary, a disgrace born, it is said, of the legendary misunderstanding between the sea and the forest. City of woe, city of love, city of cocoa built on a mirage and on bitterness. *Bidjan-là-même* is the type of inconvenience that becomes indispensable once one has tasted its eccentricities and its hard virtues."[4]

Music pours out of the bars onto the pavement and it is not unusual to see people dancing in the street. Laughter and shouting resound through the quarter and children run about heedless of the traffic. Car horns blare at the slightest provocation. People live outdoors without any misplaced sense of propriety and there is nothing on the other side of the walls, which are in any case inexistent in poor quarters, that is not public knowledge. The sense of propriety exists, but elsewhere-in everything that remains unsaid. This notion of "scandal" in which family quarrels are conducted in public is nothing but a sign of the reality of life-a familiarity or sense of family in a meaning of the word that has been lost in the West. It is the necessary scandal, in all its physical, social and economic dimensions, that constitutes the essence of the city-a city in which, in spite of the absence of any apparent sense, everyone has his place.

This improbable social coherence in Africa's cities is something of a miracle. Anyone who has taken a taxi in Lagos, Cotonou or Kinshasa and watched the city rolling past under his feet because the floor of the car had holes in it, anyone who has wondered at the cobblestones that even a scrap heap in Europe would have no use for will know what I am talking about. The art of survival, *se débrouiller*, is an everyday necessity that can be observed on all rungs of the social ladder. Nothing is thrown away. A use can be and is found for everything. Nothing escapes this parallel economy, the art of making do. Picasso never thought that any particular colour was indispensable but claimed to be able to work with anything that came to hand. If, like Picasso, we believe that art is nothing more than an accident of this kind, an everyday miracle, we will also agree that the city in Africa is a work of art. This contemporaneousness, whose mechanisms neither the artists nor the few critics or historians interested in this continent's art have been able to decipher, hampered as they are by an Eurocentric definition that nips all experimentation in the bud, is no more than an ability to bounce back, recycle life and create avant-garde objects out of old materials and even older ideas.

But let us return to this notion of scandal, which raises a number of questions on which I believe we should dwell for a moment. The first image that comes to mind is that of immodesty. Scandal born of immodesty is a social phenomenon that clashes with the principle of nature and culture. In Judaeo-Christian society, scandal contains an implicit moral judgement. I am reminded of a song by Jacques Brel in which he speaks of windows acting as cinema screens or peepholes or as something to hide behind, which leads me to conjecture on the moralistic function of buildings in Western societies. We hide things in buildings that we don't want others to see. We hide our riches in safes and banks, we hide our old people in old age homes, we hide the mentally ill in madhouses, we hide behind doors to dance, drink or eat-as if it were morally reprehensible to show our humanity, or maybe "animality" would be a better word. Africa doesn't have this tradition of hiding-even if it has regrettably begun to develop in this direction.

As the photographs by Bouna Medoune Seye in Dakar or Dorris Haron Kasco in Abidjan show, the mentally ill, for example, are an integral part of the cities. Their dirty rags, dishevelled hair, their eyes full of agitation that we cannot soothe, don't appear to harm anyone. It is as if there were nothing human that is alien to the people here. The distorting mirror held up to us by the mentally ill and continually reminding us of our own neuroses is brotherly and coherent. There are so many things in Africa that a person who walks on his own two legs remains a person. Michel Foucault points out that to turn away and make judgement is to deny

the fundamental essence of nature: "In the medicine of species, disease has, as a birthright, forms and seasons that are alien to the space of societies. There is a 'savage' nature of desease that is both its true nature and its most obedient course: alone, free of intervention, without medical artifice, it reveals the ordered, almost vegetal nervure of its essence. But the more complex the social space in which it is situated becomes, the more denatured it becomes. Before the advent of civilisation, people had only the simplest, most necessary diseases."[5]

The city is a complicated variation of traditional social space, and the shock of civilisation tends to create schizophrenic personalities, torn between the reality of this encroaching civilisation and the certainties with which they grew up. This dichotomy produces "madness". We might even go as far as saying that the very notion of madness, like the epidemics that decimated "primitive" peoples at the start of the age of discovery, is a highly cultural notion created by Western psychiatrists and psychoanalysts. "Madness" in Africa is not comparable. The Western God is dead, dismantled into individual components by culture, but African gods are alive and keep watch. Possession is a holy act to which people still surrender in religious ceremonies. In this environment, it is completely normal and it is only when it is transferred to neutral territory that it becomes suspect. But the line between a holy act and a disease is not clear. To outsiders, Africa might appear crazy because nature is never far away, for all the urbanisation that might have taken place.

In the West, a disease must first of all be defined, and this act of definition is like a prerequisite for acknowledgement of the disease at all by society. To put it another way, an ill that is not named or capable of discussion does not exist. Everything depends on a perception of the "patient" and a verbalisation of his symptoms. Intellectual perception has priority over sensory perception. Crazy people, madness, the way others see us. According to the psychoanalyst Jacques Lacan, these others define us and tell us who we are. Western perception is based on guilt and the Judaeo-Christian ideas of morality, it is a perception that judges and condemns. There is no room for disorder. Robinson Crusoe, finding himself abandoned on a desert island, had no more pressing desire than to recreate the rules of civilisation that he had lost—as if beyond the perception of others, beyond the code of behaviour rooted in the collective subconscious, chaos and madness reigned. It is interesting to note that in this philosophical fable, Man Friday, Crusoe's black companion, represents the "world before history" as Hegel puts it, the world of animism. Like Adam and Eve before the Fall, Man Friday is a happy creature. He has not the slightest yearning for civilisation, which he cannot miss because he's never known it. He is neither a slave of a normative society nor of cultural ideas, to use Freud's terms: "It was discovered that a person becomes neurotic because he cannot tolerate the amount of frustration which society imposes on him in the service of its cultural ideals, and it was inferred from this that the abolition or reduction of those demands would result in a return of possibilities of happiness."[6]

At the crossroads of a large town in Africa, strange posters with haunting prophesies: Jesus, Bill Clinton and Lady Di next to African presidents, as if they were part of a new gospel. At the foot of these posters is an altar adorned with flowers and a man who appears to be putting the finishing touches to what might be called an "installation". His name is Gabriel and he styles himself as an artist and prophet. Passers-by in the town glance at him in amusement. As far as they are concerned, Gabriel is crazy. He is expressing his love for his dead wife, Princess Diana. His works cover the entire town like Cabbalistic signs reserved for the initiated. They blend in with the scenery and can be spotted only by the most attentive. Gabriel talks with a smile on his lips to passers-by who stop to look at his works. In carefully chosen words, he explains the essence of his work. In spite of the smile that keeps breaking out, there is no hostility or feeling of danger whatsoever. Gabriel is simply a symbol of the schizophrenia produced by the town that appears in various degrees of severity, culminating in some instances in dementia. Gabriel's conversations, however anecdotal they might be, remind us of a recurring facet of African society: to be excluded is to die. Existence has no meaning outside the context of society, and within this society, individuals are accepted for what they are. Even if people point their finger at you, even if you are vilified and insulted, this is still a tangible proof of your humanity. Disease is the only thing that can justify "removal" from society. In the tertiary spatialisation process defined by Foucault, madness in Africa is not a disease: "Let us call Tertiary spatialisation all the gestures by which, in a given society, a disease circumscribed, medically invested, isolated, devided up into closed, privileged regions, or

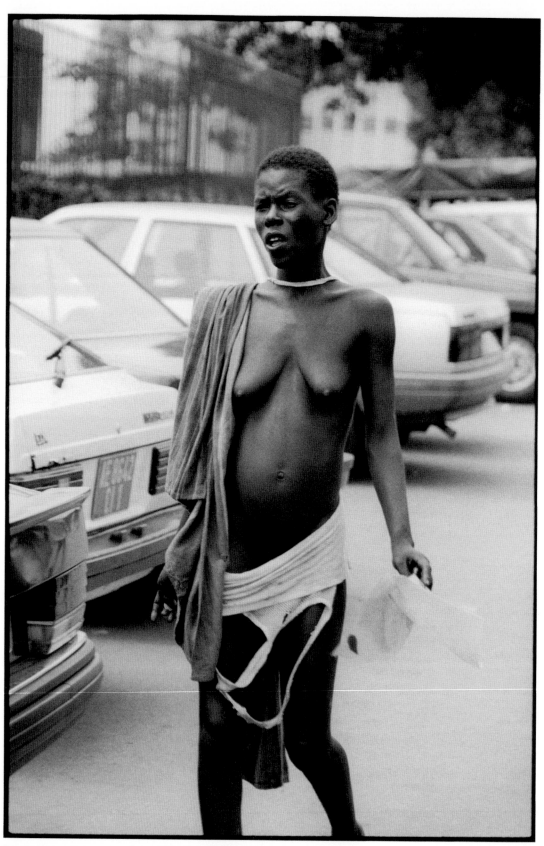

Dorris Haron Kasco, Les fous d'Abidjan, 1990–1993

distributed throughout cure centres. 'Tertiary' is not intended to imply a derivative, less essential structure than preceding ones; it brings into play a system of options that reveals the way in which a group, in order to protect itself, practises exclusions, establishes the forms of assistance, and reacts to poverty and to the far of death."[7]

Exclusion is an important word. Africa doesn't exclude anyone. Perhaps it is lucky to have remained poor and close to the essence of humanity, which is its richest asset. In spite of family planning, which is curiously reminiscent of the dictates of the World Bank or IMF, families have not yet abandoned their thousand-year-old traditions. An aging mother is not yet carted off one sunny day to an old people's home to be visited once a week if she's lucky. She can die in her son's house because he cannot conceive of getting rid of her and condemning her to a dark asocial realm. Children live on the streets. Rich and poor alike live their lives to the full without any other obligation than to survive. It would be wrong to expect that progress in a continent that doesn't have the means to look after its inhabitants can be measured in terms of the number of new mental asylums built to remove crazy people from the streets and lock them away. We have already noted that discontent is an almost obvious synonym for civilisation. A society that publicly displays its contradictions without shame or ado is one that still believes in itself, one in which indifference has not taken over.

"Where do we get this strange practice and peculiar idea common to all modern penal codes of locking people up in order to correct them? Is it the heritage of the dungeons of the Middle Ages? In fact, it is a more recent technology introduced between the 16th and 18th centuries. A whole arsenal of procedures to control, measure and train individuals and to make them docile and useful."[8]

Michel Foucault is talking here about prisons, but there is something familiar about it. These procedures could also be applied wholesale to psychiatric hospitals. When we look at the lost faces on the photos of Bouna Medoune Seye and Dorris Haron Kasco, it is difficult for us to image how these human beings with their fragile beauty could survive for even an hour shut up in a universe where communication is restricted to elementary and banal gestures. The only luxury they know is the sun that caresses their skin. And they expose this nakedness to the prudish eyes of the world like kings–the absolute liberty that a human being can achieve only if it manages to detach itself completely from its own ego.

Notes

1 Jean Chevalier/Alain Gheerbrant/Robert Laffont, "Dictionnaire des Symboles", Paris, 1982, p. 458
2 Tierno Monénembo, *Un Attiéké pour Elgass*, Paris 1993, p. 17
3 Sigmund Freud, "Civilization and its Discontents", in: *The Standard Edition of the Complete Psychological Works*, London 1971, Vol. XXI, p. 86
4 Tierno Monénembo, op. cit., p. 39-40
5 Michel Foucault, "The Birth of the Clinic: An Archaeology of Medical Perception", London 1991, p. 16
6 Sigmund Freud, op. cit., p. 53
7 Michel Foucault, op. cit., p. 16
8 Michel Foucault, "Surveiller et Punir", Paris 1975, blurb

Ideas have no boundaries

The Senegalese fashion designer Oumou Sy. A conversation with Wolfgang Kos, 2000

Wolfgang Kos: Mme. Sy, some years ago you created the first Internet Café in Dakar under the name of Metissacana: I am under the impression that the name refers to some cultural vision.

Oumou Sy: That is correct. The name derives from "*métissage*", which refers to a mixture or a bastardisation. But *métissage*, in my reading, stands not only for the mixing of colours or sounds, it also comprises everything that constitutes different cultures. The connection between European and African culture, the dialogue between modern technologies and older, traditional cultures–all this results in mixtures that I want to designate by the word "metissacana."

Kos: Is this idea of *métissage* also an important concept for fashion? In fashion design, as you know, it always depends on who does the mixing. In recent times it would appear that fashion designers like yourself no longer wait to see what's happening in New York or Paris, and instead come up with their own hybrid forms of design.

Sy: Creative people are creators whether they are African or European. If you limit yourself to only one country or one continent, you set up boundaries for yourself and reduce your possibilities. But ideas have no boundaries; they are in the air. Exactly the same thoughts can come to my mind as to a European fashion designer. But once you have developed your ideas, you must also act on them and translate into action what you merely thought of, otherwise somebody will come along and do it straightaway. Thinking, however, cannot be limited, and *metissage* is part of the creative act. For the same reason, we cannot say that we are African and will restrict ourselves to the African continent. That just won't do, for no-one can move ahead in this way. Everyone can find something in another country that they don't find in their own. If I see a European design for a dress, I can easily outfit it with some African accessories and so create something new. It is this very exchange that is so interesting.

Kos: I saw a photograph of a very interesting creation in your cyber café: a dress, which was decorated with grapes and calabashes. One gathers the impression that not so much the article of clothing is the issue here, but how to present the figure of the entire person.

Sy: There are, on the one hand, the *prêt-à-porters*, i.e. the kind of dress that one puts on to go to the market, or to a wedding or to a ball. And then there are fashion designs that are supposed to create an impression. Clothes conceived as a spectacular event! When I create a design, I first try to find out what the customer wants to achieve with it. If someone says to me, she wants to shock people with a dress, then I'll act accordingly. I do not have a problem with that. A woman once said to me that she wanted a dress made from coconuts and bananas, so I obliged her. Other designs were manufactured from phloem, from wood and the bark of the baobab tree, from different lichens or from cherry trees. Those are all materials from the heart of Africa that I know very well, because I grew up in the Casamance region in the south of Senegal. When I opened the cyber café Metissacana, I designed a cyber dress, using CDs and laser-discs as materials. Also, as an African, I can express myself without any problems by employing modern technologies. I am self-taught and for that reason have no inhibitions and preconceived ideas. I simply do what I want to do.

Kos: You are today a general practitioner of ideas, someone who makes many different things, ranging from fashion and design to the cyber café. What I would like to know is, how did you start out? What gave you the courage to take the first professional step?

Sy: I never consciously aimed at being a professional or becoming famous. I started out with my work already

at the age of five. At that time I was very ill, and had been so from birth. In the place where I was born, the temperature rarely drops below 45 degrees centigrade in the shade. I suffered from heat allergy, an illness, which is very unusual in Africa. My parents could not figure out at all, why I was so ill. The people from the village came by each day, to see whether I had made it through the night. One day my father lost his temper and he yelled at them: "You are getting dreadfully on my nerves. One day Oumou will bury the lot of you." I was five years old when my father died. His death came as a shock to me and I literally aged by 20 years right away. I knew now that I had to find something to do for myself, now that my father was no longer there to take care of me. And so I began to make dresses for my dolls and to discover colours and shapes. I even had to make my own scissors, because I had always been told to keep my hands off knives and blades. I also drew up articles of clothing for my younger brothers and when I was ten years old, I had my first local customer. At age twelve, I set up my own studio; but I still haven't finished my education. I keep on trying even until this very day to go on developing myself further. I've never learned to read and write, and so my fashion is the most important vessel for the expression of my creativity.

Kos: Why is fashion so important to the young culture of Africa?

Sy: On the one hand, fashion is simply a part of everyday life. What ever else may happen, one still has to get dressed each day, exactly the same way one has to eat everyday. Fashion will never be out of fashion, it will always be in fashion. In addition, there's the fact that the youth, particularly in Africa, wants to express itself through its clothes. They are trying to find a form that will convey to the outside what it is they feel inside. For this reason, the young people have also a very idiosyncratic and differentiated style. The rappers, of whom there are a lot in Dakar, have a unique look, which differs from that of the more traditional musicians. Everybody wants to show a different facet and to convey a quite personal message.

Kos: Best known in Europe is your *haute-couture* designs, the unique pieces. Do you also create items of clothing that are serially produced?

Sy: Yes, and I also do quite a few things on order, such as necklaces, which go to European markets. Some customers want jewellery, others like accessories or bags. Occasionally I even get orders for textiles, which are used for curtains or upholstery. Whether or not my work is artistic, I cannot rightly tell myself, but I design stuff for the cinema, the theatre and pop musicians like Youssour N'Dour as well. A further facet of my work concerns the reconstruction of the costumes worn by African queens and kings. This is something I have been involved with for over 30 years now. Museums occasionally buy such royal garments from me, but I always produce an extra copy because I want the "real" museum of these articles of clothing to remain here in Senegal.

Kos: Are these actual historical dresses, or are they fantasy costumes?

Sy: These are articles of clothing that really existed at their time. But I have had to reconstruct them because they have not retained all their characteristics. Let me tell you the history of one particular royal costume and a royal amulet in order to explain to you why this reconstruction work is so complicated. When one produces an article of clothing for a king, the work process already begins when cultivating the cotton. The person who cultivates the cotton is someone special, he has to be a member of a chosen family. At the same time, two girls are selected who have to have been born at a specific time and who will be given the task of weaving the material for the king's garment. When the girls are 14 years old, the cotton is picked: starting in the morning when the sun is quite round and stopping in the evening, when it becomes round once again. Then the girls, who must be virgins, begin to weave the cotton and finally they are given to the king as wives. The costumes are thus not made from normal materials, but from a special material with its own history. The same applies to pieces of jewellery and amulets. In addition, there is the story of two warriors who originated from very wealthy families with large herds of cattle. One had an amulet, which made each arrow he fired hit the bull's eye, while the amulet of the other one ensured that no arrow would ever hit him. It came to a fight between these two warriors: the first one fired his arrow at the second. Though the projectile did not kill him, it

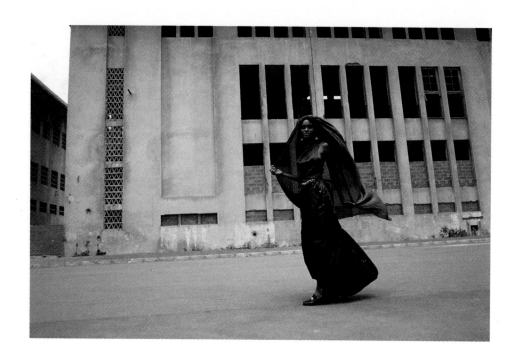

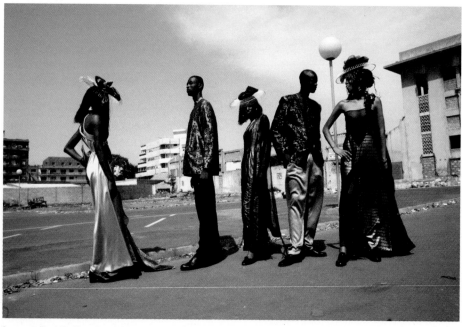

Oumou Sy: Collection 1997, photo: Mamadou Touré Béhan

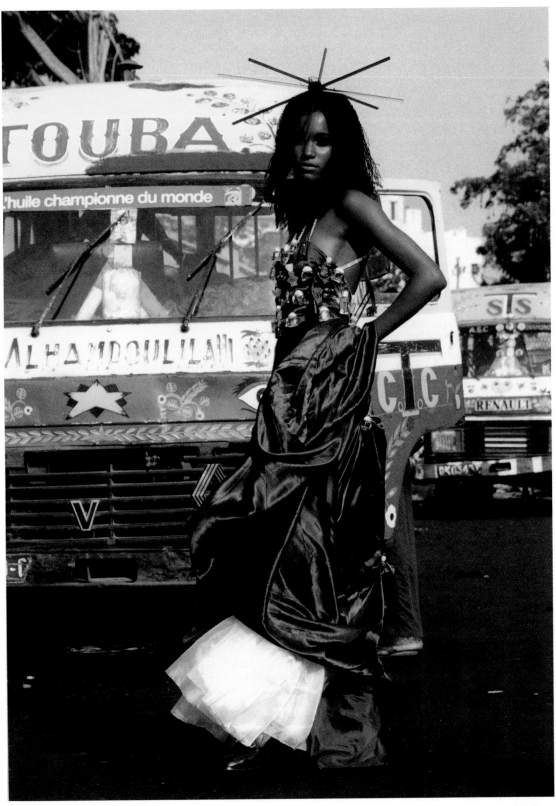

Oumou Sy: Collection 1997, photo: Mamadou Touré Béhan

continued to buzz around his head. Even when he died, the arrow found no peace and incessantly circled around his coffin. Only once the last piece of his amulet had crumbled when it was gnawed to dust by termites did the arrow finally drop down on his coffin and come to rest. It is stories such as these that are contained within the dresses. One only hears about them from the narratives of the old cronies, who for their part had heard them from their ancestors. A researcher could never dig up such stories that easily.

Kos: Mme. Sy, you are the co-founder of a carnival in Dakar, where some of the dresses are presented in the streets. Can one organise such a thing in a predominantly Islamic country without too many problems?

Sy: I gave the name "carnival" to this afternoon performance, because any other name for it would not have been understood by anybody. Is it compatible with Islam? I believe so, because Islam is very tolerant. Usually it's only people who do not know Islam that have problems with it. I am a complete and total Muslim, my mother descended in a direct line from the prophet Muhammad and my father was a member of the Sy family, which represents the Islamic faith in black Africa. Islam did not forbid the carnival, but only the excesses around the carnival. We are Africans, which means that we have two religions. First there was animism, whose positive aspects continued to exert an influence even after the advent of Islam. While on this subject of the carnival, I must add that Africans only work if they have fun doing it. So when I founded my studio, which is a training centre for classical and modern manufacturing techniques, I introduced the carnival at the same time, in order to be able to show to the people in the streets what was being manufactured over the course of the year. Where I lived as a child, there was no distinction between public and private spheres. There were no border disputes over areas of responsibility. People danced together, they amused themselves together. And if a house was built, it was the same: while one did the digging, the other one moistened the soil; if all hands joined together, the house was soon completed. We cannot take over new techniques and at the same time forget our traditions, that just won't wash. Apart from that, I just think that it is no good to organise a fashion show in a hall and to leave those who don't have the money to remain outside.

Kos: You also started a school for fashion design. I can imagine that this is very important for young designers. Is it your hope that fashion design will generally assume an important position in Dakar some day?

Sy: I try to convey to my students how fashion is made. My own pace of learning was very slow, so I would wish to accelerate it a little now. As to your question: I believe that fashion work and new technologies will strongly contribute to the development of Africa. We have already arranged for 200 sewing machines from France and are about to equip 17 larger and smaller villages with learning centres. 200 jobs are being created this way. We succeeded in acquiring these sewing machines very cheaply. In France, broken appliances are given away to the unemployed. They repair them, and we buy these machines from them. I employ 50 people in my workshop, who receive the raw materials and get a wage. We sell the goods that we produce through the Internet at low prices. In this way, the fashion develops and everyone gets a fair deal. Markets, which are today in the Far East, could just as well be in Senegal, in Guinea or in Mali. If the infrastructure is right, the markets will also follow. One of my students won a prize in Johannesburg recently–the prize of the Golden Scissors. Another one is on her way, even as we speak, to Brussels, to participate in a competition of jewellery makers. We teach manual and machine weaving here, jewellery production, basket weaving and facial make-up. For all branches of industry looking for someone, we have the suitable people right here.

Kos: Is it important to you that as many fabrics as possible are manufactured here in this country? Traditionally many fabrics have come from Holland, England or even from Austria.

Sy: I am proud of the fact that in the meantime we have begun to produce many fabrics ourselves. My using Senegalese products, however, is a far cry from saying I am wedded to them forever. That would mean narrowing my perspective and limiting myself, and I do not want that. As you know: I'm all for exchange, for mixture. I am for the *métissage*.

Koyo Kouoh

Frozen mobility. A photographer in dialogue with his environment

A foot in close-up, captured in agitated motion against a vast and expansive background. An arm revealing the unshaven armpit of a woman and in the background the reason for the fervent activity of this city dweller who left her village long ago. The penetrating and distrustful look in the eye of a street vendor in Dakar, taken from a bus racing against time. An old man sitting at the threshold of his small room, watching time go by and contemplating the stories that were passed on from generation to generation.

This was my first encounter with the world of Boubacar Touré Mandémory. I was already familiar with other photographs by Africans of his generation, a word that refers here not so much to age as to the moment when different forms of creative expression became perceptible. No other photographer on the continent appealed to me more. His direct language, stripped of the exoticism of the inexperienced eye, spoke to me instinctively of an Africa that we are all still in search of.

Touré has deliberately chosen the thorny path of an artist in an environment that holds no store for creativity and even less for photography as an art form. Fully automatic Japanese cameras that flood the markets all over the world have debased the snap shot in his eyes. He has also distanced himself from a pretentious art world that celebrates its success in spaces overflowing with postmodern art and is lost in a frantic race for the best position. "I know that I will die poor", he says to me one afternoon in the course of an animated conversation about his fundamental decisions in life. I suggest studios and agencies to him. He declines graciously adding that he could just as well photograph marriages and baptisms where people are so desperate to immortalise their vanity. His reply to my reaction that such pictures may not be art but would at least pay for food was even more negative. "I am in search of life", he says, "and life is not to be found in an orchestration planned and studied in advance." And yet, this is how Touré had started out. He ran a flourishing publicity agency in the 1980s. There were plenty of orders and the cash was pouring in. But one day he simply stopped. Abandoning the suit and tie, he put on his photographer's vest and walking shoes again, slung his cameras across his shoulders, stuffed his pockets with rolls of film and then set off in search of images. This is how his photo reportages on neighbouring countries including Guinea-Bissau, Guinea, Sierra Leone and Mali came about.

But where was the structure to put a value on this incessant work? Nowhere. So the negatives kept piling up and found their way into every corner of his house on the outskirts of Dakar. Pictures that speak the eloquent language of silence, moments that tell stories, dreams and nightmares, worry and enjoyment, like that of young bathers in the ocean that surrounds Dakar. The frustration at not having a means of distribution prompted him to set up a joint business with local colleagues with similar aspirations and approach to photography. "Nataal", the photographer's agency, was born. "Nataal" means "view" in Wolof. It was to have been a media based distribution agency for African photography, in this case *Dakar Soir*, a newspaper that started out as a weekly but became a daily very quickly. Not being sufficiently equipped at the time, it ran out of breath equally fast.

Always ready to embark on a new adventure, to explore a new country or environment, Touré became interested in the *"La caravane de la poésie"* (Caravan of Poetry) project that I was setting up. It was through this project that we finally met. As someone with roots in Mandé and Djollof, he adores Mali. In 1994, Bamako offered him a platform during the *"Rencontres de la Photographie Africaine"*. Timbuktu was a dream that he wanted to capture with his camera. The route of the Caravan, as it passed through places charged with myth and history, gave him so much inspiration for photos that he was ready to sacrifice valuable time to capture them. Touré is a nomad and the nomadic character of this moving literary workshop naturally attracted him.

With the merciless sands and winds of the desert as its weapons, nature fights its own battles against the human race. The people defend themselves by continually creating new civilisations. They use their memory to survive in remote areas and to preserve the life and dreams of the human heart. Words are like nomads

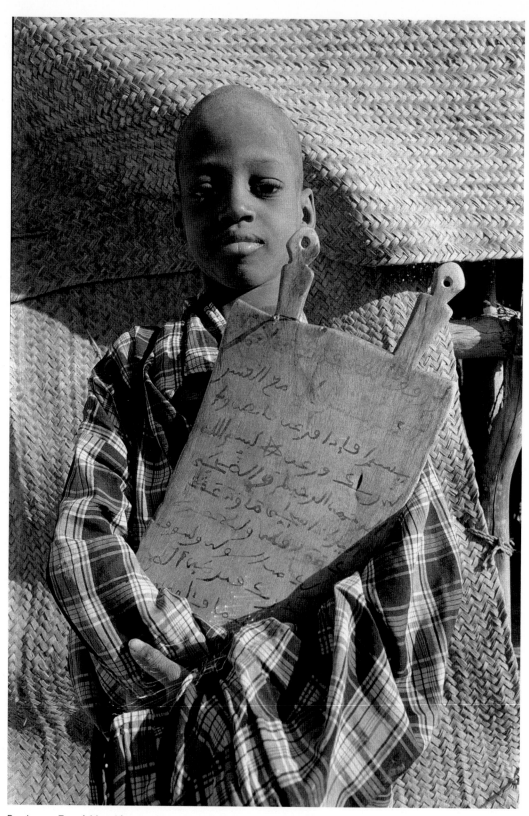

Boubacar Touré Mandémory, La caravane de la poésie, 1999

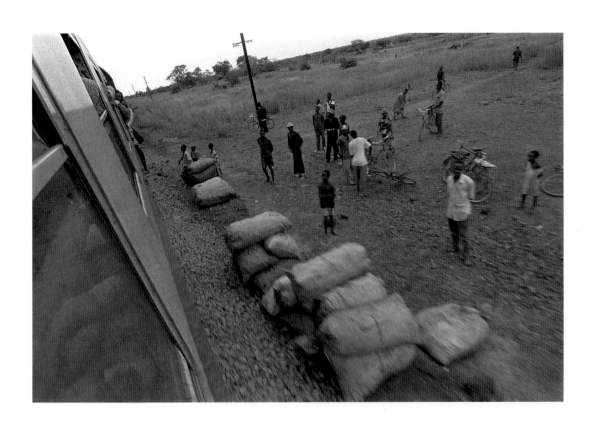

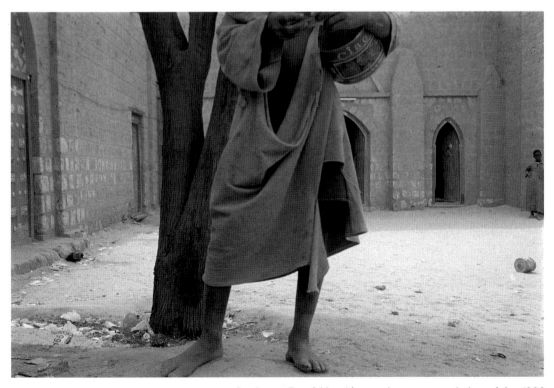

Boubacar Touré Mandémory, La caravane de la poésie, 1999

that cross frontiers looking for new ways of life. The "caravane de la poésie" was thus a quest for the voices, the gentle whispers and images that had made the empires of West Africa known throughout the world.

The photographer shared the road with the poets, weaving a visible and invisible, static and moving fabric, with the modest eye of the observer. Along the 2500km long route stretching from the Isle of Goré to Timbuktu, Touré repeatedly distanced himself from the group. He was never where we wanted him to be. He never asked anyone to pose. And yet the photographs he took of his subjects were so intimate. And there was no shortage of subjects: Breyten Breytenbach from South Africa, Were Were Liking from Cameroon, Chenjerai Hove from Zimbabwe, to mention but a few. He stayed so much in the background that halfway through the trip I began to wonder how his films would come out.

While the Caravan recuperated from the strains of the arduous journey, he still had enough reserves. He would set out in search of the shepherds minding their sheep, fishermen repairing their nets, women selling tea and tending their fires, boatmen guiding their *pinaces* and irate drivers caught in traffic jams in towns they could not cope with. After all, for him not we were the real caravan, but everything else that took place outside it.

The poets taking part in the "caravane de la poésie" were celebrating the ability of words to transcend those material and emotional barriers, which are artificial obstacles created by an error of human judgement. The idea of entering the new millennium with words and songs was also an affirmation of the ability of words to survive in spite of the turmoil that has the world in a deadly embrace.

The Caravan left Île de Gorée one sunny morning under the clear blue sky that is typical in the Sahel after a heavy rain shower. We had a long journey ahead of us that would connect two poles of African history. The route passed through ten historical and strategic stations, including Kita, Ségou and Djenné. Wherever they went the modern poets met their traditional counterparts, the *griots*: storytellers who, in their day, combined singing, dancing, music and recitation to create living images of their time.

Just the way the desert people thirst for water the poet thirsts for words, tirelessly on a quest for the source where great minds meet and exchange their visions and dreams–be it Timbuktu or another well in Buktu. As the desert people wandered from one oasis to another, their memories also changed and merged with other stories. They celebrated these stories in song. Their movements thus became a caravan of words and songs, a heart yearning for things future or past.

The end of the Caravan for this companion, always on the look out for new horizons, was typical. After having caressed the mysterious city with his discreet lenses, Boubacar Touré Mandémory left us to answer a new call.

Glossary

Djollof: precolonial name for northern Senegal
Mandé: precolonial name for a region including the southern Senegal, northern Guinea and eastern Mali
Pinace: large boat for transporting goods and people on the Niger

Ryszard Kapuścińsky
The shadow of the sun

A day in the village of Abdallah Wallo

Mornings in Abdallah Wallo are not accompanied by the barking of dogs or the clucking of hens or the lowing of cows. There is not a single animal in the village, not one creature that one could describe as being livestock-cattle, domestic birds, goats, or pigs. As a result, there are no barns, stables, pigpens, or henhouses.

There is also no vegetation in Abdallah Wallo, no greenery, flowers, or shrubs, no gardens or orchards. Man lives here one-on-one with the bare earth, loose sand, and crumbling clay. He is the only living creature in the hot, blazing emptiness, and is wholly preoccupied with survival, with the effort to remain aboveground. There is man, and there is water. Here, water takes the place of everything else. Because there are no animals, it nourishes and sustains; because there is no shade-producing vegetation, it cools; its splashing is like the rustle of leaves, the murmur of shrubs and trees.

I am the guest of Thiam and his brother, Yamar. They work in Dakar, where we met. What do they do? Different things. Half the people in African towns don't have defined occupations, permanent jobs. They sell this and that, work as porters, guard something. They're everywhere, always at one's disposal, ready to serve, for hire. They perform their task, take their wages, and vanish without a trace. Or they can stay with you for years. That depends on you, on your money. They tell rich tales about what they have done in life. And what is it that they have done? Thousands of things-everything, really! They stay in the city because it is easier to live there, and one can earn something now and then. If they manage to make a few pennies, they purchase a few presents and travel home, back to the countryside, to their wife, children, cousins.

I met Thiam and Yamar just as they were preparing to leave for Abdallah Wallo. They proposed that I go with them, but I had to stay in Dakar for another week. If I wanted to come after that, however, they would be waiting for me. The only way for me to get there was by minibus. I must arrive at the bus terminal at dawn, they admonished, when it is easiest to get a seat.

So, a week later, I went to the terminal. The *Gare Routière* is an enormous, flat square, still empty at this hour. A group of young boys materialized instantly at the gate, asking where I wanted to go. To Podor, I said, because the village I was traveling to was in the department of that name. They led me to more or less the center of the square and, without a word, left me there. Because I was alone in this desolate place, a group of vendors, shivering in the still cool air (the nights are cold here), gathered around me, pushing their wares-chewing gum, biscuits, baby rattles, cigarettes, sold individually or by the pack. I didn't want anything, but they kept standing there; they had nothing else to do. A white man is such an anomaly, a foundling from another planet, that it is possible to stare at him with interest almost forever. After a while another passenger appeared at the gate, then one more after him, and the vendors moved off in their direction.

Finally, a small Toyota van pulled up. These vehicles are built to seat twelve, but here they accommodate more than thirty passengers. It is difficult to describe the number and nature of all the additions, the welded-on extensions, the little benches inside such a bus. When it is full, for one passenger to either get out or get in, all the others must do so as well; the intricate calibration of the internal arrangements is as tight and precise as the workings of a Swiss watch, and whoever occupies a seat must take into account the fact that for the next several hours, for all intents and purposes, he will not be able to move so much as a toe. The worst are the hours of waiting, when one must sit in the hot, airless bus while the driver collects his full ensemble of passengers. In the case of our Toyota, this process lasted four hours. We were just about to set off when the driver-a powerful, well-built young man named Traoré-announced upon getting into the bus that someone had stolen a package that had been lying on his seat, with a girl's dress inside. Thefts like this are a common occurrence the world over but Traoré fell into such a rage, a fury bordering on insanity, that we all cringed, fearing that he would tear us-innocent passengers!-limb from limb. It was yet another instance of something I had observed in Africa before: the reaction to a thief-although there is plenty of theft here-has

an irrational dimension, akin to madness. Because there is something inhuman about stealing from a poor man, who often has but one bowl or one tattered shirt, that man's response to the theft can likewise be inhuman. If a crowd catches a thief in the market, on the square, on the street, it can kill him on the spot—which is why, paradoxically, the task of the police here is not so much the pursuit of thieves as their protection.

Madame Diuf Is Coming Home

At first, nothing portends what is to come. At dawn, the train station in Dakar is empty. There is only one train on the tracks, which will leave for Bamako before noon. Trains rarely arrive or depart from here. In all of Senegal, there is only one international rail connection, to Bamako, the capital of Mali, and only one short internal one, to St. Louis, with a train running once every twenty-four hours. Most frequently, therefore, there is no-one at the station. It is difficult even to find the cashier, who, reportedly, is also the stationmaster.

Only when the sun is already high in the sky do the first passengers appear. They take their places in the compartments unhurriedly. The cars here are smaller than in Europe, the tracks narrower, the compartments more cramped. At first, however, there is no shortage of seats. I met a young couple on the platform, Scots from Glasgow, who were traveling through western Africa from Casablanca to Niamey. "Why from Casablanca to Niamey?" They have difficulty answering. That's just what they decided. They are together, and that, it seems, is enough for them. What did they see in Casablanca? Nothing, really. And in Dakar? Nothing much either. They are not interested in sightseeing. They only want to travel. Travel and travel. What is important for them is an exotic route, and experiencing this route together. They look very much alike: pale complexions, which in Africa look almost transparent, light brown hair, many freckles. Their English is very Scottish, meaning that I understand little of it. For a while, it's just the three of us in the compartment, but right before departure we are joined by a heavy, energetic woman in an ample, puffy, brightly colored *bou-bou* (the local ankle-length dress). "Madame Diuf" she introduces herself, and settles herself comfortably on the bench.

We set off. At first, the train rolls along the edge of old, colonial Dakar. A beautiful coastal city, pastel-colored, picturesque, laid out on a promontory amid beaches and terraces, slightly resembling Naples, the residential areas of Marseilles, the posh suburbs of Barcelona. Palm trees, gardens, cypresses, bougainvillea. Stepped streets, hedges, lawns, fountains. French boutiques, Italian hotels, Greek restaurants. The train, gathering more and more speed, passes this showcase city, enclave city, dream city, then suddenly, in the space of a second, it grows dark in the compartment, there are loud thudding, crashing sounds outside, and we hear blood-curdling screams. I lunge at the window, which Edgar, the young Scot, is trying unsuccessfully to slam shut in order to keep out the clouds of dust, garbage, and debris forcing their way in.

What has happened? I can see that the lush, flowering gardens have disappeared, swallowed beneath the ground, and a desert has commenced, but a populated desert, full of shacks and lean-tos, sand upon which sprawls a neighborhood of squalor, a chaotic and swarming district of slums, one of the typical, depressing *bidonvilles* that surround most African cities. And in this cramped *bidonville*, the shanties crowd one another, press together, even climb up on one another; the only open space for a market is the train tracks and embankment. It's busy here since dawn. Woman display their merchandise on the ground, in bowls, on trays, on tables—their bananas, tomatoes, soap, and candles. They stand next to one another, elbow to elbow, as is the African custom. And then—here comes the train. It arrives at full speed, unchecked, thundering and whistling. And then everyone, shouting, terrified, panicked, grabbing whatever they can manage to, starts to run as fast as their legs can carry them. They cannot move out of the way earlier, because no-one knows for certain when the train will arrive, and, moreover, one cannot see it from a distance: it comes barreling out from behind a bend. Thus there is only one thing to do: save yourself at the last minute, in those seconds when the enraged iron giant is already coming at you headlong, rushing like a lethal rocket.

Through the window I see the fleeing crowds, the frightened faces, hands instinctively raised in a protective gesture. I see people falling, rolling down the embankment, covering their heads. And all this in clouds of sand, flying plastic bags, shreds of paper, rags, bits of cardboard.

It is some time before we finish rushing through the market, leaving in our wake a trampled battlefield and billowing dust. And people, who no doubt will now try to restore some semblance of order. We come to a spacious, peaceful, unpopulated savannah, on which grow acacias and blackthorn bushes. Madame Diuf says this moment when the train knocks down and, as it were, blows up the market is ideal for thieves, who are lying in wait for just this moment. Taking advantage of the confusion, concealed behind the curtain of dust raised by the train wheels, they pounce upon the scattered merchandise and steal as much as they can.

"*Ils sont malins, les voleurs!*" she exclaims, almost admiringly.

I tell the young Scots, who are on this continent for the first time, that in the last two to three decades the character of African cities has changed. What they saw just a moment ago–the beautiful Mediterranean-like Dakar giving way to the frightful desert Dakar–is an apt illustration of this change. In the past, the cities were administrative, commercial, and industrial centers, practical constructs, performing productive, creative functions. Typically of moderate size, they were inhabited only by those who had employment there. What remains of these cities today is merely a shred, a fraction, a fragment of the former cities, which even in small and thinly populated countries have expanded monstrously, become great metropolises. True, urban centers the world over are growing at an accelerated pace, because people pin on them their hopes for an easier and better life. But in Africa additional factors came into play, which further intensified this hyperurbanization. The first was the calamity of the drought that descended on the continent in the 1970s, and then again in the 1980s. Fields were drying up, cattle were perishing. Millions of people were starving to death. Millions of others sought salvation in cities. The cities offered a better chance of survival, because international relief supplies were distributed here. Transport in Africa is too difficult and costly for such supplies to reach the countryside; therefore, the inhabitants of the countryside must journey to the city in order to take advantage of them. But once a clan abandons its fields and loses its herds it will not have the means to regain them. These people, now permanently condemned to depend on international relief, will live only as long as it is not interrupted.

The city also tempted with the mirage of peace, the dream of safety. This was especially so in countries tormented by civil wars and the terror of warlords. The weak, the defenseless, fled to the cities, hoping to increase their chances of survival. I remember the little towns of eastern Kenya–Mandera, Garissa–during the Somalian war. When the evening approached, Somalis arrived from pastures with their herds and converged around these hamlets, which each were encircled by a glowing ring of lights: it was the newcomers burning their lamps, tallow candles, torches. They felt calmer closer to a town, more secure somehow. At dawn, the band of lights died out. The Somalis dispersed, walking with their herds to distant pastures.

That is how drought and war depopulated villages and drove their inhabitants into cities. The process took years. It involved millions, tens of millions, of people. In Angola and in Sudan, in Somalia and in Chad. Everywhere, really. Go to the city! It was an expression of hope, and also a gesture of despair. After all, no-one was waiting for them there, no-one had invited them. They came spurred on by fear, with the last ounces of strength, just to find a hiding place, to be saved somehow.

I think of the camp we passed leaving Dakar, of the fate of its residents. The impermanence of their existence, the questions about its purpose, its meaning, which they probably do not pose to anyone, not even to themselves. If the truck does not bring food, they will die of hunger. If the tanker does not bring water, they will die of thirst. They have no reason to go into the city proper; they have nothing to come back to in their village. They cultivate nothing, raise nothing, manufacture nothing. They do not attend schools. They have no addresses, no money, no documents. All of them have lost homes; many have lost their families. They have no-one to complain to, no-one they expect anything from.

Excerpt from: Ryszard Kapuściński, "The Shadow of the Sun", Penguin UK, London 2001, pp. 212-214 and 270-274

Photography as a window to the world

An e-mail correspondence with Philip Kwame Apagya about the art of stage production and about the therapeutic aspect of studio photography by Tobias Wendl, 2001

In a painting by Chéri Samba entitled "La femme et ses premiers désirs"[1] the observer can see a young woman sitting comfortably in her home. She is surrounded by all the conveniences of a consumer society: armchair, occasional table, fitted cupboard, hi-fi equipment, fan and refrigerator; the television is situated almost exactly at the vanishing point. There is a similar composition in Sembene Ousmane's Film "Xala" (1974) in a marriage scene. The exaltation of the bride through the *griot* songs of praise are reflected symbolically by the stacks of consumer goods in the foreground, in particular the television, which here too stands as the central focus and window to the world. While Samba's painting can be seen as an ironic comment not only on materialism in Zaire, but also on the relation between the sexes that turns men increasingly into hunters of consumer trophies for their demanding wives, the Senegalese consumer fetishism in Ousmane's film shows the other side of the impotence of the husband and protagonist El Hadji in the form of a critique of the alienation of the local elite—as an allegory for powerlessness[2].

In Philip Kwame Apagya's studio photographs, the situation is more complicated. Apagya is a photographer of the old school; his pictures, which he sets up in the studio against a background of large, painted tableaux, have been ordered by customers. In other words, they are themselves consumer goods on a small scale and—at least originally—not designed for circulation on the Western art market. The enticements of the modern consumer world, which repeatedly force themselves into his pictures, reflect African consumerism, which he even caricatures occasionally, although not as an intentional form of cultural criticism. His pictures are rather in the portrait tradition of Félix Nadar, August Sander, James Vanderzee or Seydou Keïta, whose works may be regarded as representative of an era or society. These portraitists can make a living thanks to the need of their fellow-citizens to be portrayed. As a necessary and accepted facet of life, they are outside the modern Western idea of art. They are service providers and intermediaries, whose task and purpose is to convey in pictorial form what their subjects wish to communicate and to help them to find the most suitable setting in which to do so. What makes Apagya special is that he perpetuates the illusionist idea to be found in early photography while also making use of the imagery of the post-modern era, the world of the ubiquitous advertising brochures and mail order catalogues. His studio in the Ghanaian coastal town of Shama resembles a dream factory with glamorously painted stage sets, which his subjects can enter into and merge with. Apagya's pictures emphasise how the unavailability of the commodities merely heightens their appeal. By transforming the mundane world of goods and glitter into icons so as to ennoble his models, he also creates the incunabula of a new, African variety of pop[3].

The vitality and vividness of his settings, the interaction of surrealism and hyper-realism, can best be described, as Luigi Zanzi[4] puts it, as "inter-realistic", since the interrelated significations are not only diverse, but also interact with one another: the models in imaginary dialogue with their pictorial environmental but also with the intended recipient (who can sometimes even be guessed at from the title, e.g. "For You!"), the systematic ignoring and overstepping of the boundary between photography and painting, the combination of ludic rebellion and striking execution, the numerous references to proverbs and clichés, the multifaceted dress codes, and finally the wonderful and amazed light surrounding the models, their infinite cheerfulness, their smiles and the repeated glimpses of (self-)irony.

Added to this is the fact that the Ghanaian set painters with whom Apagya works (Daniel Anum Jasper and Archibald Donatus Hippies), while "sampling" and "recycling" Western advertising models, base their designs on local textile art. The vast arrangements seem almost to shimmer and sway. In spite of the perspective, they are striking and flat. In the picture "Francis in Manhattan"; for example, the skyscrapers have nothing of the cold anonymity that we associate with our cities. The colouring, variation of building and window shapes, distribution and depth tend rather to evoke the tension and flow of a textile pattern. Or they are reminiscent of the

polyrhythms of Highlife, in which the individual rhythms derive from a basic beat, which itself is not played. Similarly, the independence and dynamism of the fetish goods placed so strikingly in the cabinets is only broken and tamed by the shelves holding them. Whereas American pop art achieves its effect through its reduction in form and the unifying grid, Apagya's studio pictures focus above all on details and their rhythmic integration. Apagya's works make us consider the synchronicity of the non-synchronous. They portray a powerful and unmistakably, visual vocabulary, a visual form of polyphony. We experience the creation of symbolic, transitory pictures given expression through the re-emergence of suppressed yearning and placing emphasis, apart from the specific subject, on the localisation of the global images of mass media culture. The pictures taken by Apagya in Milan with Italian models differ from the studio photographs from Shama, in particular in their subjugation to fashion, but they also mark a new level of pictorial communication in which mimetic differences relating to the models' habitus become apparent (see "Cucina Italiana", for example). Apagya's pictures, which sing the praises of the foreign, absent and global, and regularly make use of the images of European advertising, are themselves placed in the service of this advertising. The same applies to the pictures taken in Shama with local models for the Italian magazine *La Donna* and the French journal *Jalouse*, but the mimetic differences here are much less pronounced. The use of Africa to rekindle and stimulate the European imagination is nothing new, but it is now being applied increasingly to design and advertising as well. Apagya's own aesthetic sensibility also follows this route, although in the opposite direction. The transnational exchange of culture and images has become more dynamic in the last few years and the familiar cultural references in pictures appear to be gradually losing their definition. Photography, which in the era of the Internet and video imagery seems almost archaic, has played a key role in this development. For Apagya it has always been a window to the world.

Tobias Wendl: Edgar Roski once compared you with a psychoanalyst who analyses the sensitivities of his fellow countrymen and then offers them appropriate pictures with which they can treat themselves[5]. Do you agree with this comparison?

Philip Kwame Apagya: Yes and no. Roski is a joker who sees and writes one side of the story and omits the other side. It is true that I have always tried to find out what my clients like best, what they dream of, what they desire, their aspirations–particularly for the future: love, job, prosperity, a home of their own, everything that is prestigious and beautiful. I cannot but repeat that beauty is our business! It started when I was one of the first to use colour regularly, at a time when traditional black and white photography was in the throes of change. Our world is colourful and so are our clothes, and colour photography was thus a logical development. People liked it and they also appreciated the additional colour in my studio, and hence in their pictures that my sets provided. I did not invent backgrounds. They have always existed in Ghana but they were black and white and old-fashioned, *"colo"* with their funny columns, steps and curtains. No-one wanted to look at pictures like that. They wanted modernising and the pictures needed an African or Afro-European reference. That's the whole secret. My classic background is the "Room Divider". Every African knows what I mean by that. Every year I bring out a new one, usually shortly before Christmas with the latest technical equipment. The people in Shama know that and thank me for it. Developments are so fast-paced that there would otherwise be a danger of seeming old-fashioned. A particularly popular item at present is my Internet Café (see "Booming Internet"). Here people can use the computer keyboard and discuss business graphics. There's no Internet Café in Shama yet and people don't even really know what it is, but they all talk about it, and that's why I thought that they would like a background like that. To return to Edgar Roski, however: I reject the idea that I am a therapist. Or if I am one, then only in the same way as a good tailor or hairdresser, if you see what I mean.

Wendl: Your work appears to have a lot to do with modern life. There has been criticisms that this makes it non-authentic. Afro-Americans in particular repeatedly claim that you devalue Africa because you show nothing genuinely African in your pictures. What do you think of this?

Apagya: Yes, I have been accused of glorifying the consumer society, of encouraging consumer fetishism and of kicking our traditional African values and cultural heritage. It's funny, I've won a prize in America but have never been invited to put on an exhibition there. It's as if they were afraid to come into contact with me. The questions by black American journalists in Bamako really shocked me. I didn't fit into their image of Africa, although my picture of Africa is one that my African clients can completely identify with. Our people are interested in modern, new things and in the future–that is the driving force and object of their ambitions, and I try to adapt myself to this. It is nonsense to say that I betray our traditional African values. The people here simply have a need to see these values in pictures. Our country is very poor and no-one wants to reflect on the past. Take the Durbar set (see "Chief Photographer"): I looked long and hard for a subject that would reflect our traditional system of chiefs in my photographs. My customers could dress up as chiefs or queen mothers for the photos. But the set never really worked–except on certain holidays; and even then I was only able to use it outside the studio. In the end I abandoned the idea.

Wendl: Can you explain how you go about taking a photo and how you ensure that the subjects will like the photos of themselves?

Apagya: That is the whole art of studio photography. Everyone has a different face. In some you can see self-irony or humour, others are serious and want something becoming or dignified. Then there are those who are unsure and don't really know what to do in the situation. You have to find out what they want. No-one likes to take a picture only to have it criticised later. It's important to break the ice early on, to chat a bit, make a joke; I call that "chilling out" the clients and making them feel normal. Then you have to find a pose in which they look good. An old man, for example, should never stand, but should always be seated. The pose must fit the clothing. Many people find their own place in the set, and others have to be shown. It's often fun, although they probably have only the faintest idea of what they look like. With some people it's almost impossible to take a good photo–people who don't react to the idea of a "good photo". There are those who are having a picture taken for someone special, like a girlfriend or boyfriend, parents, or someone in another country. Then we have to decide together how best to convey the intended message. I believe that the most important thing in our profession is to be open: to have an open door for our customers, and an open ear for their suggestions and criticisms.

Wendl: Can you tell us something about your clients and also about Shama, the town you have lived and worked in for 20 years?

Apagya: My subjects are men and women, old people, young ones, all kinds. But most are women. They come for a photo with every new dress they have. Women are vain, they always want to show how beautiful they are. But they are also my greatest critics. Women have been the undoing of many photographers because they will do anything to get the pictures free of charge, they will trap you and try to seduce you. If you're not careful … My studio here in Shama is not as big as I would like it to be, nor is it as big as its reputation. I have been working here since December 1982. In those days everything was in black and white. I had two apprentices, first Sakyi, then Francis, both great guys who always worked well. Shama is a port and fishing town. The entire economy is based on fishing and fish processing. If the catch is good, the people have money to spend. The population is very mobile, many people are away for months, either at sea or selling their fish. The week normally starts slowly and gathers momentum towards the weekend, particularly at the end of the month when burials and other functions converge. Business is usually very good then. Sometimes I take two rolls of film a week, other times I can do ten or even more. There are also seasonal fluctuations. The festival season between August and January is the best. I am the only established studio photographer in town. There are a few young men with their own cameras who offer some competition, but because they don't have their own studios it is not serious. The only tourist attraction in Shama is Fort San Sebastian, which was built by the Portuguese in 1640. There is a big hotel and a small restaurant, also recently opened. Shama is 228 km from

Accra, the capital, and 22 km from Takoradi, the third largest city in Ghana, where there is a laboratory where I develop my films and have them printed.

Wendl: In the last few years you have travelled extensively in Europe. You have been at festivals and you had exhibitions, photographed models in Italy and occasionally set up your studio and photographed museum visitors. What do you think of Europe? Do you think that people understand your pictures there? Or are there misunderstandings? And how has your work at home in the studio been affected by your experiences in Europe?

Apagya: The last two years have been very busy. Sometimes I have had to fly to Europe twice a month. It's tiring but I enjoy it. The big difference between Europe and Africa is the way life is organised. Everything is completely structured and regulated. People are always doing something. No-one has time to take an interest in his neighbour. There are no photo studios any more, at least not in the cities. The few that I saw were in smaller towns. Nor were they really accessible, everything was by appointment, or you had to telephone first. I sometimes think that Europeans have forgotten the fun of photography and that they invite me so they can find it again. As an African you are always suspect and the police are always stopping you. England was the only place that was different, and it seemed more liberal in that respect than the continent. I had always imagined Europe as a gigantic supermarket and I used to think that it must be very easy to make a lot of money quickly. And then I saw how hard my fellow Ghanaians worked there and the unattractive jobs they had. But back home no-one will believe you if you tell them that. I no longer tell people that I'm going to Europe, otherwise they all come and ask me to bring things for them. Exhibitions are very nice and a good experience as well. In my opinion, Europe remains the world centre of photography. It was there that photography was invented and spread to all parts of the world, and most often it returns there. Photography brings Europe to Africa and Africa to Europe; it is like a window through which one can see another world. What I like most about Europe is the modernity, things that I can take home in the form of pictures and use to make new sets. I have sometimes been annoyed at critics (often my own fellow Ghanaians, by the way), accusing me of marketing Africa's under-development and buttering up Europeans and their feeling of superiority. But these reactions are rare. Most exhibition visitors understand my pictures as they are intended. Sometimes they need a little bit of explanation. One thing that is regularly misunderstood is the fridge. Europeans often think that my room divider is a cooking niche. But in Ghana the fridge is usually in the living room and the kitchen is generally outside, in front of the house. What they don't see is that the pictures are not simply "art for art's sake", but pictures contracted by the subject for a specific person–the recipient. In Europe I have learnt that it's good to experiment and try out things that might seem off-beat at first, and to break taboos occasionally. One example is my bathroom set (see "Auntie Monica's Bathroom", 2000). No-one in my town would think of having themselves photographed in the bath. It would be offensive: the bathroom is an intimate place, perhaps the most intimate place there is. On the other hand, the bathroom is a place that occupies the thoughts and imagination of Ghanaians a lot at the moment. Everyone would like to have a modern bathroom with tiles and the latest fittings. The arterial roads in our towns are lined with huge billboards advertising all kinds of things for the bathroom. So I had the idea of doing a bathroom set. And, as you can see, it works.

Wendl: You once mentioned that people in Ghana are now copying your style? Who are these people and what do they copy?

Apagya: I discovered imitators last year in Biriwa and Mumford in the central region. The photographers had made copies of my room divider and fitted kitchen. I pretended not to recognise them and asked the name of the artist who had painted this fantastic set. It turned out to be Hippies from Elmina. I visited him and made it clear that I would not allow him to copy my sets for other photographers. If he continued to do so, I wouldn't give him any more orders. I couldn't claim copyright, of course, but I still do the sketches myself and then give them to artists to complete.

Wendl: Which other photographers have influenced you most? Which do you admire? And what are your plans for the future regarding studio photography, fashion photography and exhibitions?

Apagya: The first question is easy to answer: my father. I learnt everything I know in his studio. In the 1960s we did the prints ourselves by hand. Wherever my father went, I went with him. I carried his stand. And because I was so small, he stood me on a chair so that I could adjust the camera. I owe my father a lot and am therefore proud that photography continues to be associated with the name Apagya. Through him, I was born into the world of photography. Other photographers whose work I have always admired include Malick Sidibé and Samuel Fosso. I have met both of them and we are good friends. For Malick Sidibé I am a son or nephew, and Samuel Fosso and I are more like brothers or colleagues sharing the same fate. All three of us come from different countries but the tradition of studio photography is the same, and we meet quite often, particularly in Europe. I like doing fashion photography and find the working conditions and professionalism in Europe very pleasant. It suits me because fashion photography is very similar to studio work. And you can earn a lot as well. Apart from photography, I also do video documentaries. A lot has been happening in the last few years and video has replaced photography in many areas. As I get older I think more about giving up my studio. One of the reasons is that women especially prefer to go to young photographers. With people of the same age they can joke and have fun, whereas they must show respect for an older person. My aim is to open my own laboratory. Then I will leave the studio work to an apprentice and spend more time on the sets or do special jobs. One of my most recent sets, for example, is one showing what Accra might look like in the year 2050 (see "Accra 2050"). It is an imaginary picture with real buildings that exist. I am thinking of doing another imaginary city with real buildings from different cities throughout the world. One thing that occurs to me, regarding exhibitions and taking photographs during them, is that Europeans have forgotten how to be photographed. They need much more encouragement and have to be shown how to pose and where to look, etc. With Africans it's much simpler.

Notes

1 Wolfgang Bender (ed.), "Chéri Samba", Munich, 1991, p. 67
2 Cf. Ella Shohat and Robert Stam, in: *Unthinking Eurocentrism. Multiculturalism and the Media.* London / New York, 1994, p. 275f.
3 See also Tobias Wendl / Margrit Prussat, "Observers Are Worried – Fotokulissen aus Ghana", in: Tobias Wendl / Heike Behrend (ed.) *Snap me one! Studiofotografen in Afrika*, Munich, 1998, p. 29-35; and Tobias Wendl, "Die Wunderkammer des Philip Kwame Apagya", in: *Porträt Afrika, Fotografische Positionen eines Jahrhunderts*, Berlin: Haus der Kulturen der Welt 2000, p. 58-67.
4 Luigi Zanzi, Disegni Animati. "Considerazioni sull'opera fotografica di Philip Kwame Apagya", in: Kean Etro (ed.) *Disegni Animati*, exhibition catalogue, Milan, 2000, p.20
5 Edgar Roski, "Le cabinet des illusions", *Le Monde Diplomatique*, February 1999

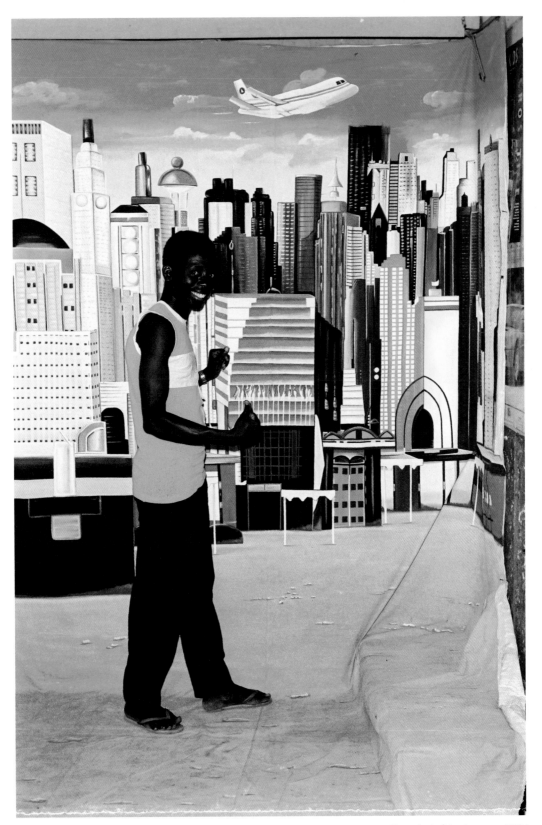

Philip Kwame Apagya, Francis in Manhattan, 1996

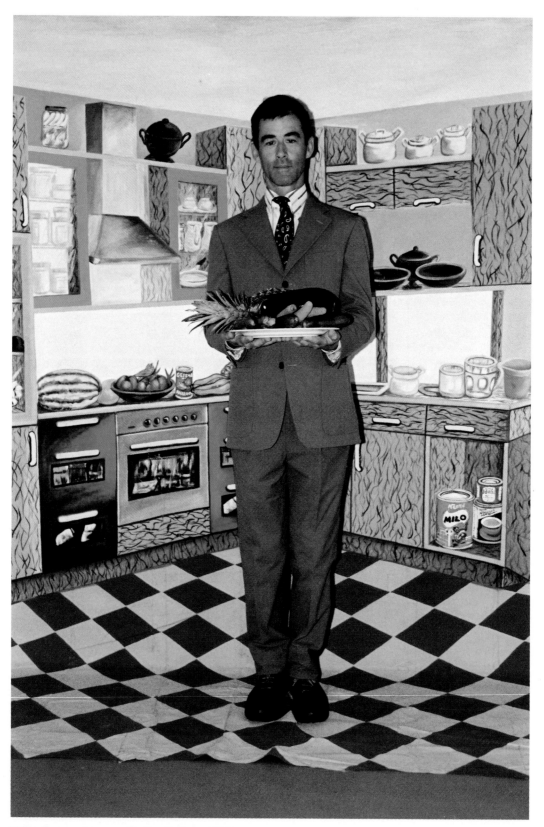

Philip Kwame Apagya, Cucina Italiana, 1999

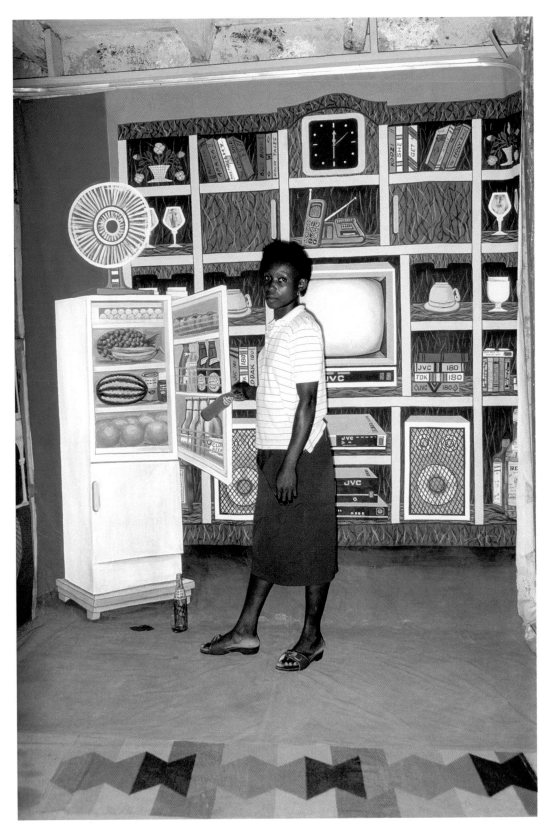

Philip Kwame Apagya, For you!, 1996

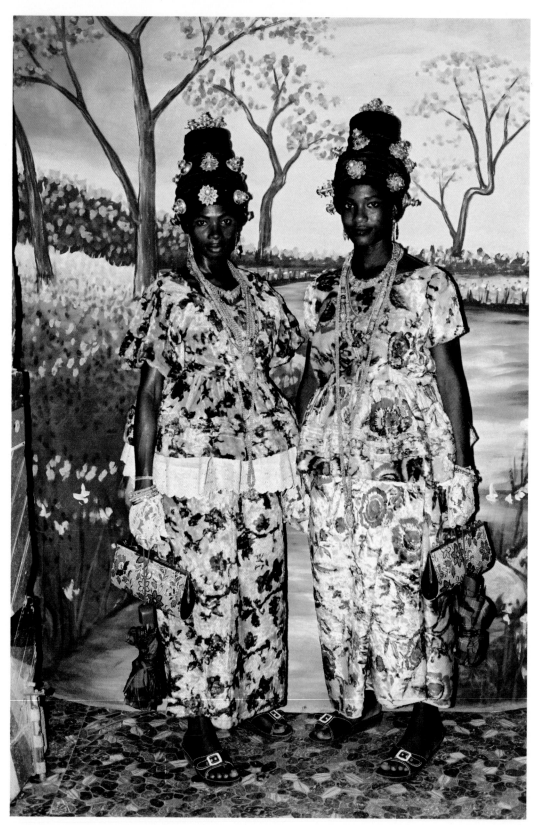

Philip Kwame Apagya, Aye for Style, 1996

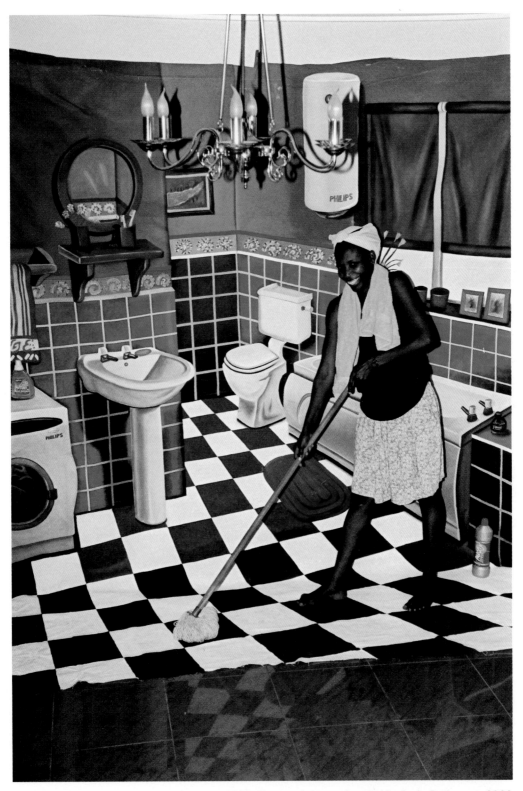

Philip Kwame Apagya, Auntie Monica's Bathroom, 2000

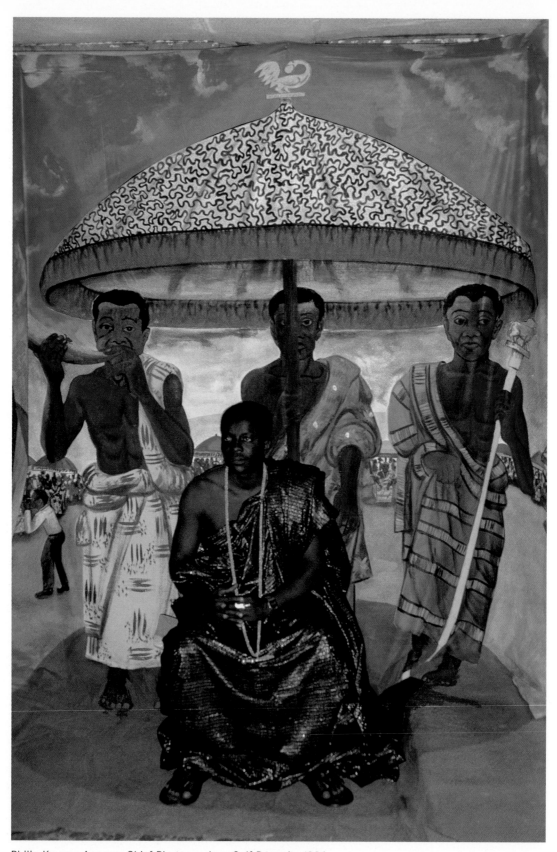

Philip Kwame Apagya, Chief Photographer: Self Portrait, 1996

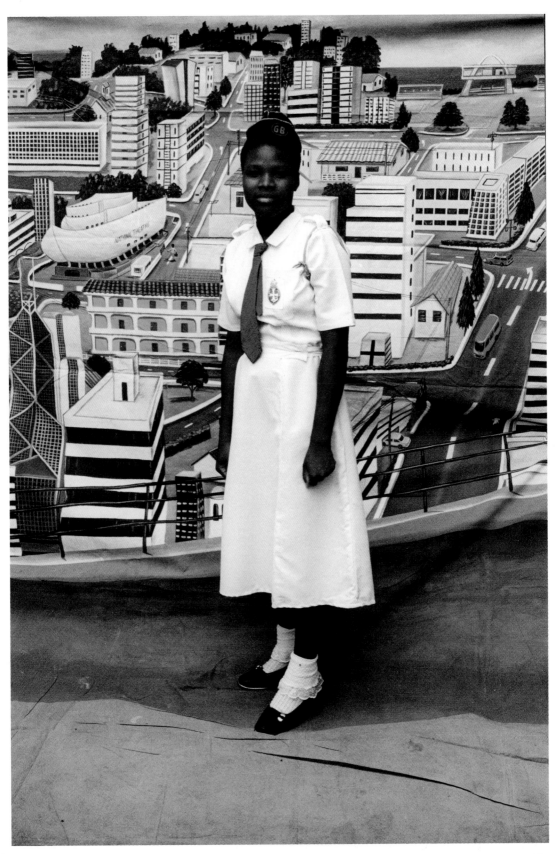

Philip Kwame Apagya, Accra 2050, 2001

The city in the mirror

Dorris Haron Kasco on the marginalised ones of Abidjan and his relationship to the old masters of studio photography in Africa. An interview by Gerald Matt and Thomas Mießgang, 2001

Thomas Mießgang: Monsieur Kasco, you became famous for your photographic cycle, "Les fous d'Abidjan" ("The Crazy People of Abidjan"). It shows people not quite in their right minds who run about through the streets of the city and who seem to be living in the midst of a harsh reality right there within their own imaginary counter-worlds. In addition to these pictures, you also made a parallel photographic series about children.

Dorris Haron Kasco: Yes, that is to a certain extent a sub-chapter of the *"fous"*. It deals with children who live on the streets, and who are considered to be "squalid". Both topics are equally important to me, and I continue to cover both. They do not have a best-by date for me. Whenever I meet somebody who leads an unusual life or with whom I share certain experiences, I try to capture some aspect of that person's life with my camera.

Gerald Matt: Do you also have a personal relationship with the people whom you photograph?

Kasco: Of course, that is the most important thing of all! Particularly when you're working with street kids. They are, after all, a part of public life. Everybody sees them, and most people consider their presence in the town's general hubbub as a kind of nuisance. But if one gets involved with these children, one soon notices that one is powerless to do anything. I tried several times to do something for them: organising small-scale soccer tournaments or giving the president of the "Fédération Ivorienne de Football" a call. He actually came by to take a look whether there might be any sporting talent among these street kids. Some of them made it into the national team of the Ivory Coast, others were able to make their way as boxers. With sport they can channel their frustrations and aggressiveness.

Mießgang: Do these children have parents or are most of them orphans?

Kasco: That depends. Some do have parents, but they abscond again and again from home because they feel unhappy there. Take for example the case of Aboudramane, a boy whom I have photographed several times: his father and his mother have no job and he has six brothers and sisters. His father used to manufacture small boxes, which he would give to Aboudramane to sell. He had to earn the money to feed the family. If he came home and hadn't sold much, he would be beaten. This happened time and again until one day he simply remained out in the street and spent the night there. In this way, he acquired a taste for it. The fact that he didn't need to fear his parents anymore was more important to him than to have a roof over this head.

Matt: Do you see your work in some major political context? The homeless, the abandoned street kids, psychologically ill people? All of these are symptoms of a society, which seems to have big problems. It's not a beautiful reality.

Kasco: You know, I don't ask myself whether the outcome of my work will be something beautiful or something ugly. What is more important to me is whether I am emotionally affected by external stimuli. And photography and the cinema are my tools, by which I give expression to this sensitivity. Quite simply, Abidjan is "beautiful" compared to other cities. By that I mean certain aspects of the infrastructure, and that there are spectacular high-rises here, large bridges and luxurious automobiles. In the centre of Abidjan, there are many mirror-coated buildings, which reflect an image of the city. I personally have problems photographing these

mirrors and saying: "*Voilà*, this is my country." Because, to me, the mirrors falsify reality, they show a distorted reality. Yet, I would like to record Abidjan, its life and its forms of existence correctly. I would like to show the people I come face to face with. They are my most truthful mirrors, in whom I see myself reflected. I do not aim at making political statements with these pictures, but perhaps I show to a certain number of individuals in my country–and it is primarily them I wish to reach through my work–the things they are unable to, or which they do not wish to see.

Mießgang: Your pictures of the *"fous"* were, after all, first shown in Abidjan. What were the reactions?

Kasco: They were very much mixed. There were people who cried, because they suddenly recognised relatives in the photographs. And at that moment, they became conscious of how these people had been, before they were pushed into a life on the skids. The more sensitive ones among the exhibition visitors perhaps even realised that they could have done more to prevent the social slide of these people. Some also congratulated me: good of you for putting this much creative energy and empathy into restoring a value to people whom everyone else just wanted to forget. The reactions to my exhibition were predominantly positive, and I also believe that it contributed to modifying the perspective on the homeless people a little.

Matt: Monsieur Kasco, this style of photography, which documents life's realities and everyday life, is relatively new to the medium in Africa and it actually only properly began with your generation. It was chronologically pre-dated by a strongly stylised and idealised type of portraiture and studio photography. Were these "old masters" who photographed, above all in black-and-white, important to you as stimulators?

Kasco: In Africa, there is an institution, called the "Rencontres africaines de la photographie", which is very active. Through it, I came into contact for the first time with photographers of the older generation, people like Seydou Keïta and Malick Sidibé. The physical presence and the pictorial invention of these artists from Mali fascinated me so much that I started investigating whether such precursors had existed in my own country, the Ivory Coast, as a result of this search, I discovered Cornélius A. Augustt, who today is quite known beyond Africa. He is of Ghanaian origin, but has worked for many decades in the north of the Ivory Coast. Augustt showed me his photographs, which he had stowed away in cardboard boxes, and I was so fascinated that I immediately began to organise an exhibition in Abidjan. These pictures could not be withheld from the world any longer.

Mießgang: The photographers of the older generation saw themselves much more as simple craftsmen who were committed to the needs of their clientele than photographic artists. Also, the warts and all view of reality did not yet exist in the forties and fifties.

Kasco: Photographers such as Keïta or Augustt, who are in their 80's today, still belong to what was almost the first generation of Africans to come into contact with a camera at all. The cameras were introduced by the missionaries, who wanted to take ethnological pictures. Some Africans subsequently understood that the magic of the camera lies much more in the mysticism of the apparatus itself than in its product; that is to say in the box, which is held before one, which one looks at and from which the picture emerges later. After independence, the need for ID pictures increased, as passports and identity cards were being issued. In the work of Cornélius A. Augustt from this time, we find, for example, several portraits that were actually intended as ID pictures. But because he used a Rolleiflex camera with a 28mm wide-angle lens at a distance of one meter, there is more to be seen in the photographs than would be necessary for a mere ID. He had to crop them in the darkroom so that the images could be used at all for an official document. In addition, Augustt also took many pictures, which were in fact conceived as portraits from the very beginning. There is, for example, a famous studio photograph of three women in identical clothes, striking the same pose. In the West, such a picture is usually interpreted falsely. One feels it to be somehow folkloristic and leaves it at that; some may

even find it a little ridiculous. And yet the meaning is entirely different. The photograph shows three women in mourning. They received a letter, in which it was indicated to them that someone in their family had passed away. But since their native village is obviously at a far distance and they cannot afford the journey to the funeral, they commission a photographic studio to depict them in a sad pose. They support their heads with their right hands. This gesture, which would be interpreted in the West as "repose", signals in Africa that one is sad. These pictures are then dispatched to the bereaved, as an expression of the message: we received your letter. We share in your mourning.

Matt: With the photographs of Seydou Keïta one often gains the impression that an idealised reality is being staged. People are shown wearing beautiful clothes, being surrounded by cars and motorcycles and luxury goods, which they obviously cannot afford to buy.

Kasco: Yes, that is one effect of modernism, which has of course also had its effect on Africa. Since the era of colonisation people no longer have any values, they must accumulate wealth and possessions, as in Western capitalism, in order to distinguish themselves. This attitude continues on today even after independence. In the old photoraphs of Keïta or Malick Sidibé one sees chic clothes, sewing machines or motorcars. With younger photographers, such as Philip Kwame Apagya, people like to have their pictures taken in front of painted refrigerators, stereo sets or computers.

Mießgang: It's almost a bit like the idea of the "dream factory" of fifties Hollywood.

Kasco: That's exactly how it was probably intended. And for the photographers of my generation the question now arises: do we simply continue in this way, with these dramatisations of personalities, which remind us of the theatre or the cinema, or do we try to invent a style of photography closer to real life? In contrast to the "old masters" we do have the advantage that our cameras are light and easy to handle—one should, after all, never ignore the technical aspect. I go out on the streets with my camera, I see a motive and click—I have captured an image. Cornélius A. Augustt could not do that with his box camera. He needed time to set up everything and to pose his customers correctly. With a situation like that, you might as well settle down in a studio for good.

Matt: In the case of the photographs of Keïta or Augustt we are dealing with work done to order. These photographs are linked to the occupation of a photographer, who has to make a living from his portraits. Whereas if you take photographs of people in the streets, then you do not work to anyone's order, nor does anybody pay for these photographs. Thus you come closer to the Western concept of the artist, who produces the work primarily for him—or herself and then attempts, through galleries, exhibitions or biennial art festivals, to become part of the art market.

Kasco: Of course, if I take photographs of children or crazy people, then this is not a marketable commodity. Also, the impression could arise that one could produce a cycle like "Les fous d'Abidjan" very quickly, perhaps within a month. But that impression is deceptive. Those pictures, which the *Revue Noir* issued under this title in a small booklet, were only a small selection from a much larger number of negatives. It took me three-and-a-half years to quite carefully assemble this body of work before I had it publicly shown for the first time. I had to also make a living during this time and, of course, I did a great deal of commercial work to order: advertisements, fashion photography, and the like. Artists or not, we all have obligations, we all live in the same consumer society. I am a photographer, I can go out and click-clack, but I cannot manufacture my own films. Those are things I have to buy.

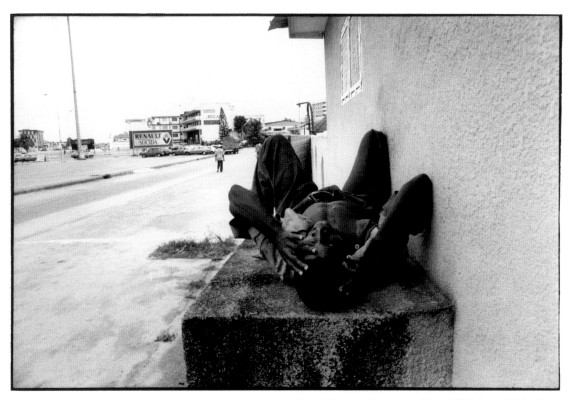

Dorris Haron Kasco, Les fous d'Abidjan, 1990–1993

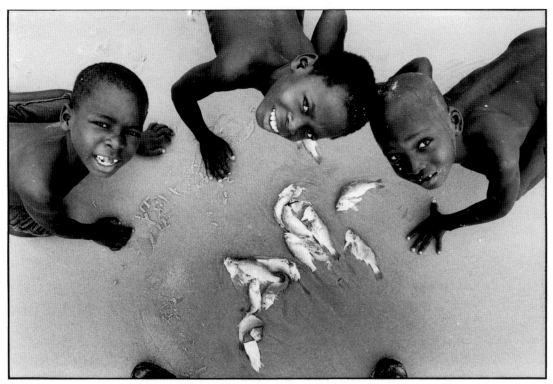

Dorris Haron Kasco, Les gamins d'Abidjan, 1995

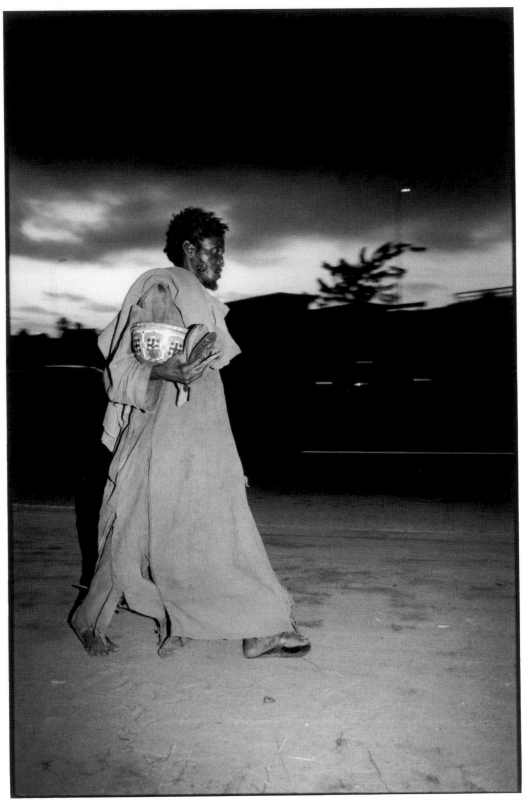

Dorris Haron Kasco, Les fous d'Abidjan, 1990–1993

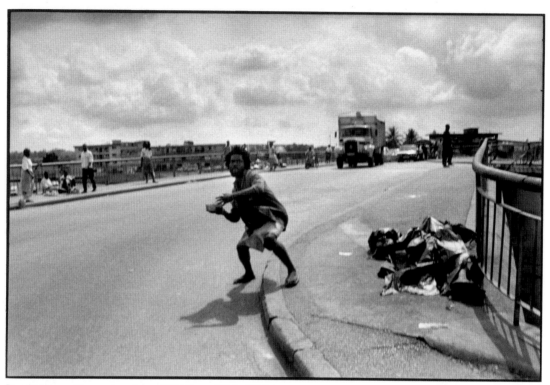

Dorris Haron Kasco, Les fous d'Abidjan, 1990-1993

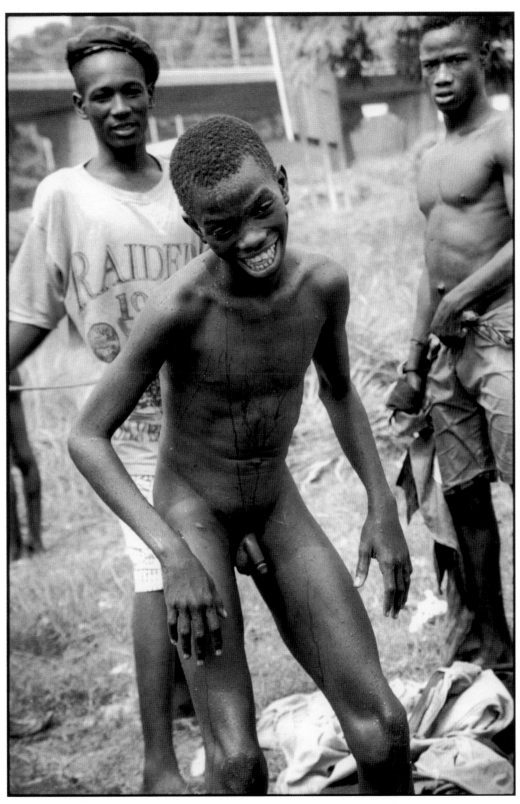

Dorris Haron Kasco, Les gamins d'Abidjan, 1995

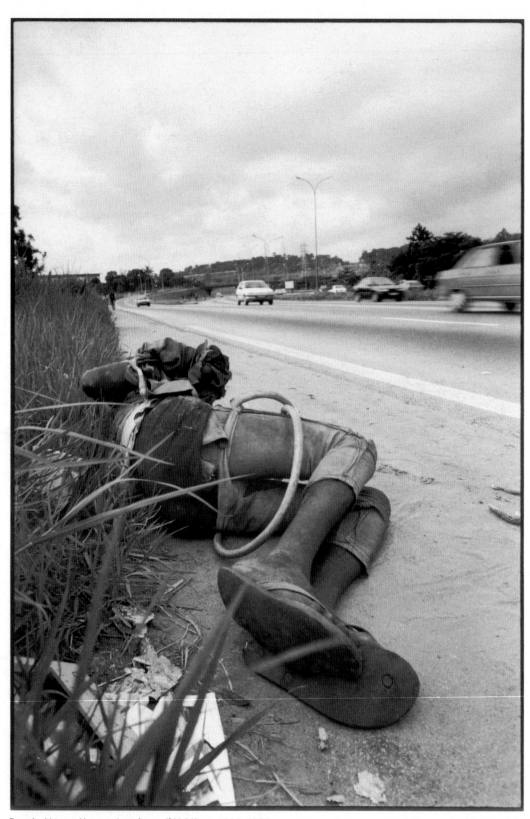

Dorris Haron Kasco, Les fous d'Abidjan, 1990-1993

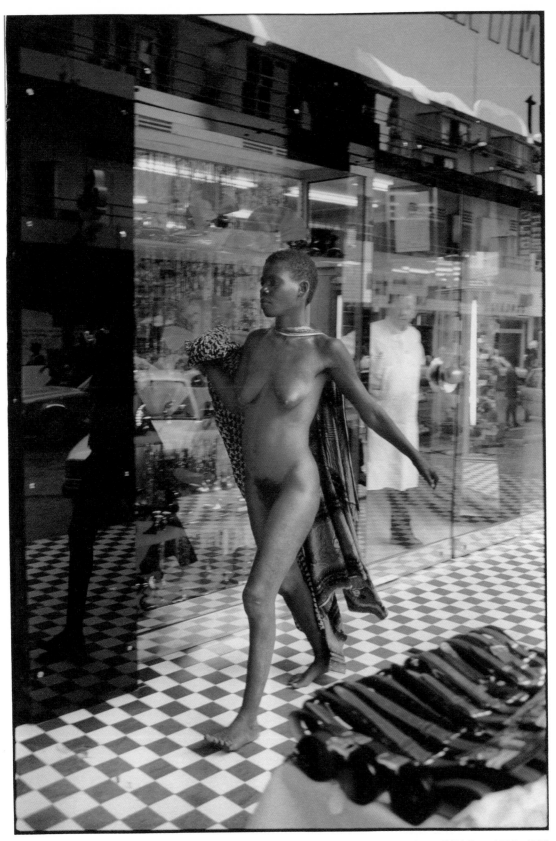

Dorris Haron Kasco, Les fous d'Abidjan, 1990–1993

Seydou's story

Excerpt from an interview by André Magnin, Bamako, 1995/96

I was born around 1921 in Bamako, right in the middle of the city. I never knew the day or the month of my birthday. I'm the eldest in a family of five children. When I was seven or eight, I realised that my father, Bâ Tiékóró and my uncle Tiémóko were educated, and appreciated for the trades that they performed well. It's thanks to them that I learned how to make furniture. I was already making furniture when I was ten. I admired my uncle so much that I was always with him. In 1935, he went to Senegal for a few days and came back with a camera. He ended up giving it to me with a film with eight shots; he never refused me anything. That's the way I began, from scratch, with no training and that German-made camera, a Kodak Brownie. I really felt that I would become a photographer, and since then, I've done everything possible to be a good one. I really liked photography. At the beginning, for at least ten years, I worked both as a carpenter and a photographer. In 1948, I set up my studio in our house in Bamako-Koura, in what was then "New Bamako" and which was a lively neighbourhood. That's where I took all the photos that you've seen. And today, I'm still there.

I started by taking photos of my family. I was already known as a cabinet maker, and when people saw me with my camera hanging around my neck, they asked me to take a photo of them. That's how I began. To take photos like that in the street caused all sorts of problems. I only did it when they asked me to do it. I also went to do portraits at people's houses. Some of the shots were flattering, others weren't so good. I got off to a bad start because people moved while I was shooting, or I was probably nervous. When the pictures came out the figures looked like skeletons. People weren't always pleased when I showed them the results. That's when things got tough, and everyone wanted to beat me up. You see I hadn't had any training at all. I asked customers to pay in advance for the prints that M. Dial, who worked for Pierre Garnier (who had a photo-supply shop and studio in Bamako), did. Because I had already given their money away, there was no way to reimburse them. I would tell them that it was their fault, because they had moved. But that didn't always work. When Pierre Garnier saw that I really loved photography, he said to me, "Hey Seydou, why don't you do this yourself?" I watched him work and that way I learned how to develop and print myself. I have to admit, however, that Mountaga also gave me a lot of advice. At the beginning, I wasted a lot of paper. Then in 1948, after Mountaga had seen that I knew what I was doing, he let me use his darkroom and each evening I went to his house in Médine to do his printing as well as mine. I had to. By this time, I had already taken a lot of photos and was becoming known.

Then my father gave me the land with the house behind the main prison. And that's where I opened my studio. It's a place where no-one wanted to live because of the spirits that threw stones during the night. Even today, if you sleep in that house and you turn off the light, a great gleaming white horse spirit might appear. You can often hear him galloping by at breakneck speed or you can see him shining in the night. I myself never had any problems because with the photography there was always a light on.

At that time, there were several photographers in Bamako: Moustapha Traoré, Youssouf Cissé, Mountaga Traoré, and Sakaly. Malick Sidibé came later. We all did portraits, but everyone said that my "sheets" were good and that I was the best photographer. I became well-known, and my publicity came by word of mouth. There were a lot of curious people who wanted to see how I worked and who had never seen a camera before. It is partly thanks to them that I had more and more customers.

I should also mention that two of my old apprentices from my days as a carpenter, Malamine Doumbia and Birama Fâné, helped me find customers. They used to go to the railway station with samples of my work looking for customers, and I gave them a percentage of the final price.

Bamako was at that time a city of about 100,000 people. It was a major crossroads then and had a really good atmosphere. People from the Ivory Coast, Burkina Faso, and the Niger all stopped in Bamako on their way to Dakar. The whole central section was very bustling because of the cathedral, the railway station, the

post office, the big Marché Rose, the Soudan Club, and a very busy zoo. My studio was in a good place. The other photographers were set up further away, and I had the advantage. A lot of people getting off the train came to me to have their photograph taken on their way to visit the zoo. That's why I was so well known in the other West African countries. They often came back and asked me for more prints, so I kept all my negatives. They are classified by date and by type (a couple together, a portrait, full-length shots…). I probably have more than 30,000 filed in boxes. This crate is completely full.

There was always a crowd around my studio, and I was working all the time. All the elite in Bamako came to be photographed by me: government workers, shop owners, politicians. Everyone passed through my studio at one time or another. Some days, especially on Saturdays, there were hundreds of people. Even our first president, Modibo Keïta, came by. Everyone knew about me. I had a rubber stamp–"Photo KEITA SEYDOU"– that everyone wanted on their prints.

Between 1945 and 1946, I bought a 6 x 9 in. box camera with glass plates. All the plates have disappeared. Then I bought a used 9 x 12 in. camera. I bought all my supplies from Pierre Garnier who sold film and Kodak and Lumière paper. I used only the Kodak. It was in 1949 that I began to work with a box camera and with the 13 x 18 in. format. That was a camera that was easy to use, and people always asked me for prints in the same format. That's why I preferred to work with the 13 x 18 in. no-one asked me for prints in the large formats of 30 x 40 in., 40 x 50 in. or 50 x 60 in. because of the price, but I would have loved to do them. Pierre Garnier had the paper and the basins needed for these large formats and did them for some of his customers. For each shot, I always made three prints. That was the minimum. When I began, the price was 25 francs for the 6 x 9 in., 100 francs for the 9 x 12 in., and 150 francs for the 13 x 18 in.

I worked with both natural and artificial light. Many people preferred the artificially-lit ones, which were paler, but I preferred natural light. In the 1950s, my price was 300 francs for the natural-light photos and 400 francs for the artificially-lit photos, because of the additional cost of the electricity. I made a good living from photography, and I even bought a Peugeot 203, in 1952 or 1953, and then a Simca Versailles around 1955. I went in it to Bougouni to get married. Those were the days. My colleague Malick Sidibé always reminds me that Bougouni was where we met.

Every so often I had to go up-country to take photos for identification cards. Because there wasn't any electricity, I put together a contraption that I could take with me and use to make my photos anywhere. I took a metal petrol barrel and made a hole in it with a slide and fitted a piece of red-painted glass which acted as a filter. Inside was a kerosene lamp which allowed me to develop my prints. That's how I printed my work in the villages. Out in the country, as soon as I took out my camera, everyone ran or turned away. It was believed to be very dangerous to have your photo taken because your soul was taken away, and you could die. Even in the city, some older people believed the same thing. Some people thought that the photographer could see them naked through the camera. I had to make them come to my studio, and once they looked through the lens, they were reassured.

Younger people, who made up the bulk of my customers, really liked my photographs because of their good quality, their sharpness and clarity. Some people said, "Look at that hair there, you can even see that!" It was probably also because the light was right and they were sitting in attractive positions. I hung samples of my work on the walls of my studio: the head of a man or woman, either alone or together, or with friends in a group, sometimes a family either standing, sitting, or relaxing. The angled portrait was my invention. I had positioned a woman like that and I thought she was really attractive, she also liked it. My customers chose their positions from the samples they liked. When they came back for their sheets, they were always pleased with the results.

They used to come without any appointment and say, "I want to have my picture taken like that one there, you see? I want that." And I would take it right away. Sometimes it didn't work out, and then I suggested something that was better for them. It's easy to take a photo, but what really made a difference was that I always knew how to find the right position, and I never was wrong. Their head slightly turned, a serious face, the position of the hands… I was capable of making someone look really good. The photos were always very good. That's why I always say that it's a real art.

To have your photo taken was an important event. The person had to be made to look his or her best. Often they became serious, and I think they were also intimidated by the camera. It was a new sensation for them. I always told them to relax more: "OK, look over here, try to smile a little, not too much." In the end they liked it. It took only about ten minutes.

When you're a photographer, you always have to come up with ideas to please the customer. My experience taught me the positions that my customers liked best. You try to obtain the best pose, the most advantageous profile, because photography is an art, everything should be as close to perfection as possible. After all, the customer is only trying to look as good as possible. In Bamako we say *"i ka nyé tan"* which in English means "you look well", but in fact it means "you look beautiful like that". Art is beauty.

I've heard that in your country you have old photographs that are like mine. Well, I've never met any foreign photographers, nor seen their photos. No information ever reached us. French or American books and magazines were very rare. The only thing I ever saw was the weekly *Les Echos d'Afrique Noire*, published by Maurice Voisin, who was known as Petit Jules; but there were no illustrations. And then there were the *Manufrance* catalogues that reached us from Dakar, but they weren't available to everyone.

I had a lot of customers every day, but Saturday was always better, sometimes there was even a queue. I made the prints at night and retouched the photos the next morning, just before my customers came back for their sheets. I didn't usually know the people who came to my studio personally, not even their names. I didn't ask any questions, because I didn't have any reason to. But I knew some of them; like this elegant young man with glasses (he put the glasses on that day to look more elegant), or the one holding the flower called Sissoko, or the big guy with the baby, that's Billaly. I remember that day: we did more than four different shots, first alone, then with him holding a baby.

Between 1949 and 1952, I used my fringed bedspread as my first backdrop. Then I changed the background every two or three years. That's how I remember more or less the dates of the shots. After that and until 1955, I used a flowery backdrop. In 1956, for just one year, I used a backdrop with leaves. Between 1957 and 1960, it was an arabesque pattern and then, until 1964, a heavy grey, neutral background. Sometimes the background went well with their clothes, especially for the women, but it was all haphazard.

It was about then that we began to lose our ancestors' culture. People living in the city began to wear European clothes, especially the men, the government workers and politicians who worked in offices. They liked to have their photo taken with stylish and fashionable clothes. Because of the heat, they would put on a traditional *bou-bou* or a shirt with baggy pockets after work. Some of my customers brought things they wanted to be photographed with. This woman with a sewing machine, or that man with his brand-new bicycle. He wanted a close-up portrait, but he also wanted to show off his new bicycle. That's why the bicycle is cut off in the photo. I had several European suits available in my studio including straight ties, bow-ties, breast-pocket handkerchiefs, shirts, hats, and even a beret. I could dress my customers from head to toe. I also had accessories available for them: watches, fountain pens, watch-chains, plastic flowers, a radio, a telephone, a scooter, a bicycle, and an alarm clock. A lot of people liked to be photographed with this kind of thing.

For women, clothing styles had not yet changed. Western dress, such as the skirt, appeared toward the end of the 1960s. Women used to come with large robes that didn't reveal their chests or their legs. Loincloths hung below the knees. I positioned the women and then spread out their dresses. Sometimes they arrived with several changes of clothing which might inspire me to choose different positions. What was important was that their jewels appear in the photos. They wore elaborate jewellery: earrings sometimes big enough to decorate the whole studio, rings, hairpieces, and bracelets in gold, coral, or amber–all the accessories that the elegant women in Bamako liked to show. Some "grandes dames" used elaborate make-up around their mouths; they were very impressive. All of these details, external signs of wealth, beauty and elegance, were of great importance. The women were very conscious of that. They also liked to show off their hands and slender fingers that were a sign of their high social standing. I had to find a position that they liked. There were some poses that only the women asked for, for example, like that woman stretched out there. A man would never have himself photographed like that.

Up until 1962, I never stopped taking my own photos. I loved the job so much I never stopped working. I always preferred black and white. When I now look at my photos, they haven't changed at all. With the colour photos it's different. I still have all of my negatives. They're all there, and my customers can ask for reprints. There were never any complaints, or they never would have come back.

In 1962, just after independence, the government was socialist and everyone was expected to work for the new state of Mali. Issa Traoré, a childhood friend, the head of the Malian police, who was called "the man with the Datsun", came to look for me. He told me, "Seydou, close your studio; the government needs a photographer." I told him, "What do you mean? You must be joking. Me, close my studio?" They told me that I was the only photographer that could work for the administration. Oumar Boré, the director general of Malian security, was more considerate. He told me, "Seydou, you can work in your studio, but only after office hours." It was prestigious for me to be asked to be a government employee. It is not something most people refuse. But in 1963 they put pressure on me to close down my studio completely, because someone working for the administration should not have any other business apart from his official work. I have to admit it put me above a lot of people and that made other people jealous. I was an official photographer until 1971, when I retired.

From the time that I opened my own studio in 1948, I saved and put in order all of my negatives that are still stored in this big chest you see there. I never found the negatives made between 1935 and 1947. I hope to find them some day at the bottom of my boxes in my old studio which is filled with all sorts of things. The negatives of the photos taken while I worked for the administration are probably in the official archives. I gave a lot of negatives to the museum in Bamako, but they never did anything with them.

Nowadays, everyone rejects black and white; colour is what they want. It's less expensive, and it's quicker. But now it's those automatic machines that do the work, and there are a lot of people who call themselves photographers. Everyone has automatic cameras, but they don't even know what developer and fixing solution are.

Since 1991, my photographs have been exhibited outside Africa in Europe, Japan, and the United States. I know that many of them are good, and it's for that reason that you like my work. I left some negatives in Europe, and I often sign prints for collectors or museums where my work is shown. I've even travelled abroad for my exhibitions, and I can see that a lot of people really like my pictures. Ever since my work has been known in your country, I've had a lot of visitors, but I prefer to leave everything up to one person. That way I can live a more peaceful retirement, going regularly to the mosque, looking after the houses I've built, and spending some time working as a mechanic, which I really like to do.

What I would like to do now is take pictures of the rural people during harvest-time and the ritual ceremonies that go on around then. That's when the essence of Mali comes out.

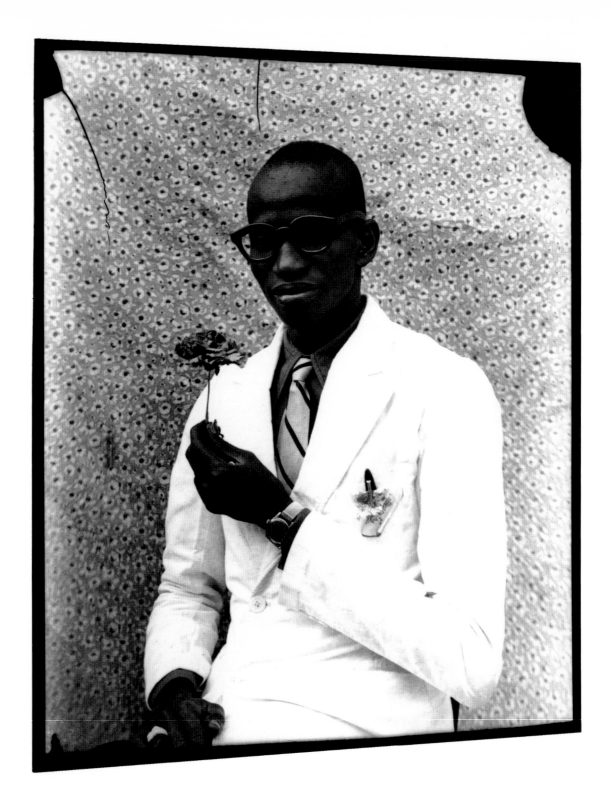

Seydou Keïta, 1959

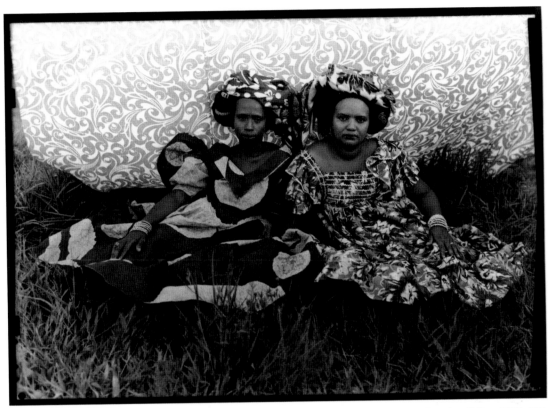

Seydou Keïta, 1956/57

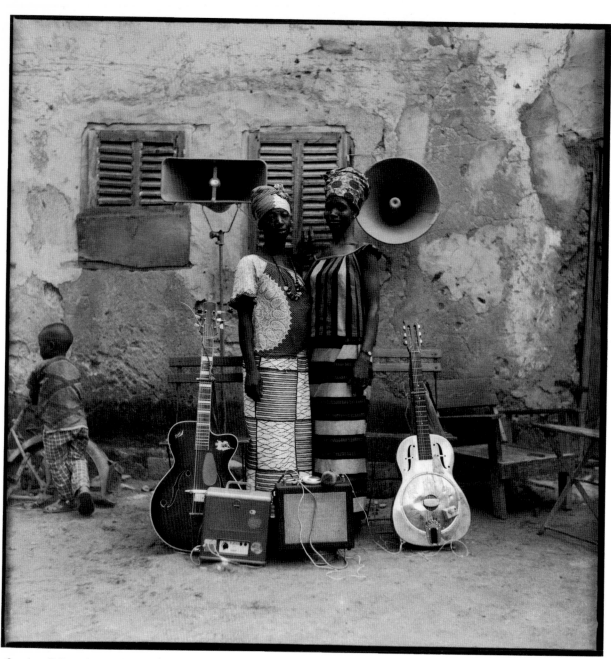

Seydou Keïta, about 1964

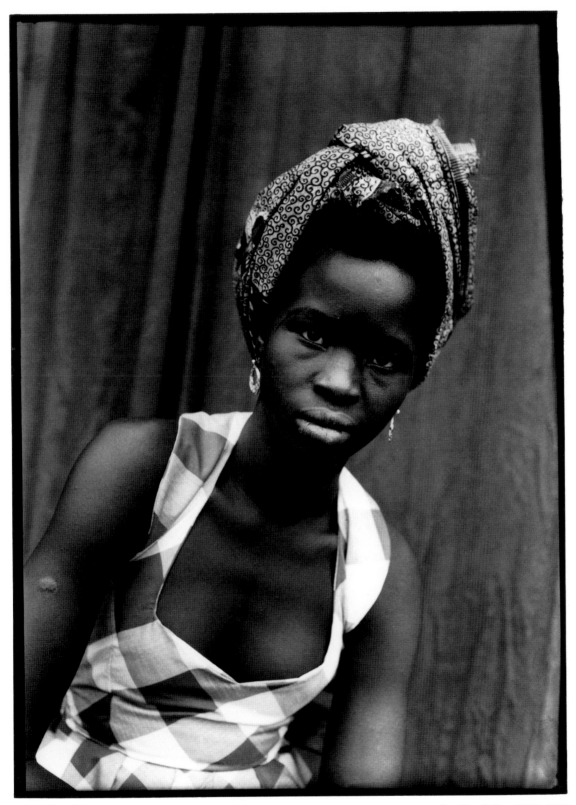

Seydou Keïta, 1952-1955

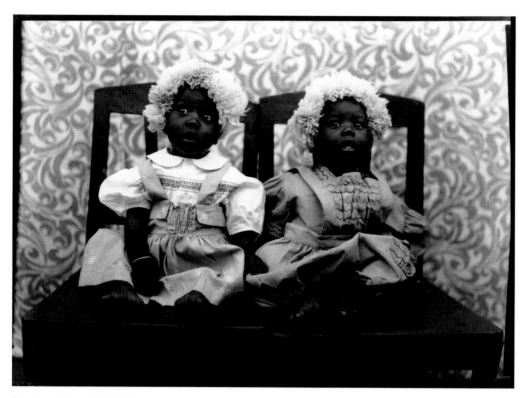

Seydou Keïta, 1956 / 57

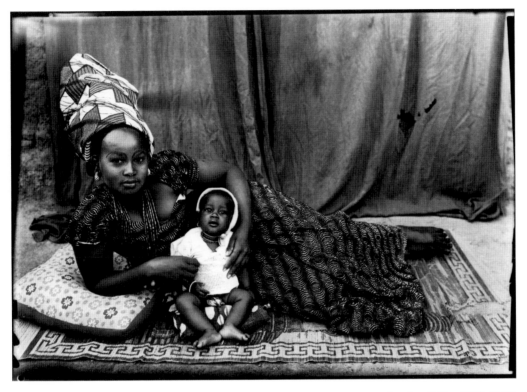

Seydou Keïta, 1952-1955

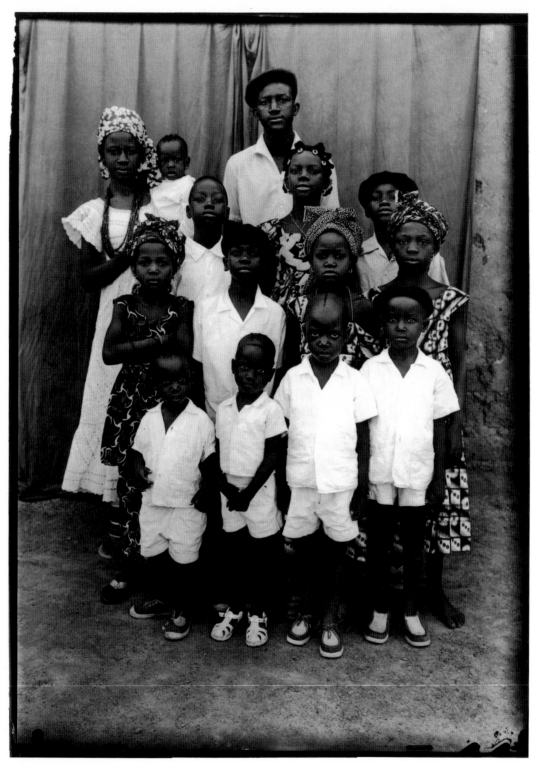

Seydou Keïta, 1954

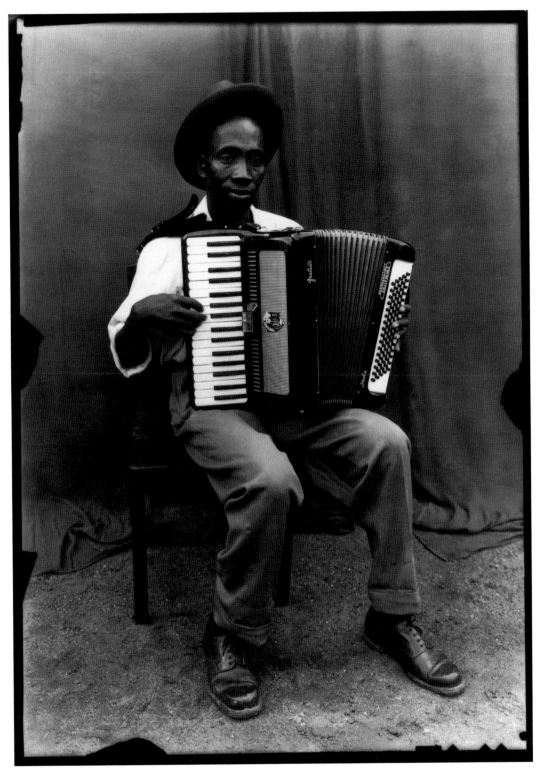

Seydou Keïta, 1952-55

"I do not like the cinema"

The Senegalese photographer Boubacar Touré Mandémory talks about the difficulties of the life of the artist in Dakar and the history of West-African documentary photography. A conversation with Gerald Matt, 2001

Gerald Matt: Monsieur Mandémory, how did you start out in photography?

Boubacar Touré Mandémory: As a child, I would always gaze at the photographs in magazines and they fascinated me a very great deal. I, too, wanted to be able to create such images. Finally, a friend got hold of an Agfa camera for me. At that time I was maybe thirteen years of age and the camera was for me something like a medium to explore the world with. I began to play around with different aperture settings and I took some photographs of my own. When I had them developed later on, other photographers told me I had done something wrong, that one had to select the exposure times and diaphragm settings differently. I tried to improve my technique, but the camera case was full of holes and there were numerous problems caused by light leaking in. I tried to fix the basic problem by sticking pieces of plastic over the holes. And so eventually my photographs came out better and better and I became a proper photographer. One day, it must have been in 1982, I told my friends: I've had enough. I have no further desire to work only for money. I would like to penetrate more deeply into the nature of photography. I want to finally become myself. So I decided to live the life of an artist. Of course, I stopped making any more money right away.

Matt: How did you live after that?

Mandémory: I neglected myself, but there was no going back. My style of clothing changed; I still wore my suit from better days, but it became shabbier and shabbier. Finally I stopped combing my hair and grew a beard. I looked rather down and out. If friends came to visit, they said anxiously: your place is a mess. There is nothing to eat, and you live in a dump. At some point I had to admit to myself that they were quite right. But what should I do now? I had given up advertising work. I had no customers, I had lost all contact with my professional colleagues. And I had to feed my family.

Matt: Did you at least have some contacts among the other artistically oriented photographers?

Mandémory: No, because they did not understand what kind of photography I was envisioning in my mind's eye. In this country, the pictures were mostly fast shots taken in the streets, which were sold for 150 CFA. But what I wanted to do was to deal with photography in an artistic way, I was interested in more sophisticated things. But whom should I sell them to? And to whom should I show them? People were not interested in them. Finally, in 1986, things gradually improved, because at that time I had my first exhibition.

Matt: Where was this?

Mandémory: In the museum, right here in Dakar. I had an exhibition with portraits of crazy people, whom I had followed about and photographed. From then on, things were on the up and up. I established contact again with other artistically inclined photographers. We discussed photography, and we improved our techniques and our artistic concepts.

Matt: And you also started up an agency at the time.

Mandémory: Yes, that was in 1989. I brought together some photographers, and we began to do work for advertising, fashion shows, industry, but following our own concepts. That worked out fine. From the very

beginning, we did not set out to serve the local market, but the demand from Europe. I had noticed that many of my colleagues had large picture files, but they were not sufficiently utilising them. They are, as it happens, very busy people and cannot worry about every detail. The agency jumped in at this point and now takes care of organisational things: the invoicing, the purchase of films, the file care, and dealing with the rights.

Matt: Is the situation concerning orders actually good enough for the agency to make a profit?

Mandémory: The situation has improved very much lately, but there is also a psychological effect. If one unites in a group, one is much stronger. By dint of the agency we are, visible to all, a part of the "economy of pictures." At last the Europeans have begun to see that there are enough photographers who can deal with the jobs here in Africa. Why should one send in a French photographer, buy him a plane ticket at around 8000 francs, pay for a 3-star-hotel and other expenses, just to come by those three photographs that are needed for a piece of reportage in the newspaper? After the agency had gained a foothold, I myself, together with a few friends, came up with the idea of the "Month of Photography", another opportunity to present our art here in Dakar. In this way agents, dealers, curators focused their attention on us. I received an invitation to the photographic biennial in Bamako. Later on, exhibitions followed in France, among other things at the Centre Pompidou.

Matt: Would you characterise your photographic style as documentary?

Mandémory: No, not really. A documentary work follows a certain line, it has a very specific conception. I do not pursue any given path, I just take my camera, focus it on those objects that attract my attention, and hit the release button. All of that happens in a very spontaneous and unplanned way.

Matt: What I find particularly noticeable about your work is the unusual choice of perspectives.

Mandémory: Do you know how that came about? The first camera that I had was a 6x6 box Brownie. With it, one can take photographs with greater depth, height, and it allows larger angles, one has the potential for figurative deformation. I love to shoot photographs from the hip or from the level of my feet.

Matt: Do you consider yourself a storyteller with the camera?

Mandémory: No, to me another aspect is more important: life consists of questions and I want to get people to ask themselves questions. I photograph banal scenes. Only if one takes a closer look does one see the unknown or strange thing that is to be found in some of my photographs and it is this that causes people to start thinking. What one sees in a photograph is not as interesting as the questions the photographer poses through it. I see the artist with the camera as a kind of animator, one who photographs life.

Matt: In our exhibition, "Flash Afrique", there is, on the one hand, evidence of a hard, documentary style of photography, which would seem to capture the authenticity of life. On the other hand, there is a highly stylised, studio-based style of photography, which would appear to arrange its human objects almost as idealised types. In other words, these are two concepts that seem almost diametrically opposed to each other.

Mandémory: African studio photography developed at a time when the reportage was still completely unknown here. People actually believed that photography's sole task was to portray a person. Anyone who had a new article of clothing, a new radio or some other prestigious article, took it to the photographer to have it documented. Seydou Keïta took many such pictures. He also always referred to himself as a craftsman and not as an artist. But in the course of time, all of these pieces of the mosaic have been added to the panorama of a whole society. Keïta's entire production is a kind of memory work documenting the various

stages of development of Mali's society. The reportage, as we know it today, is a relatively recent phenomenon in Africa. The French arranged for photographic services in the fifties and the Information Ministry at the time tried to re-train the portrait photographers into reporters with a camera. But this scheme never quite succeeded. The studio photographers came out into broad daylight carrying a canvas and so took their pictures completely in the old style. News photography, as we know it today, developed only in the course of the past three or four decades. Let me remark on yet another thing: I do not believe that a confrontation between "unreal" studio photography and "authentic" documentation is meaningful. Even Keïta's photographs contain chunks of reality: they show the manner in which people actually lived. Dreams, too, are a part of life.

Matt: Bouna Medoune Seye and Dorris Haron Kasco, whose work likewise is on show in "Flash Afrique", both also work with film, and video. Is that a possible future prospect for you as well?

Mandémory: No. A photographer is a photographer. A film producer is a film producer. I once met Jean Rouch, the greatest French documentary film-maker, in Paris. He said to me: "Touré, if you want, stay with me and we could be making films together. I will teach you all the technical skills you would need." I answered: "Monsieur Rouch, I do not like the cinema. I would like to remain in Africa and take photographs."

Matt: So what are your next projects?

Mandémory: At the moment I am working on a photographic series about initiation rites in Africa. What do these rituals mean within African societies? What are the advantages, what are the disadvantages? The moment a modernisation process sets in, people begin to forget who they are. Our job is to check out what is important in African societies. Why are we losing our value systems? Why do we have so much genocide? Why is there such strong aggression and at the same time a tremendous lethargy, which paralyses people? Many Africans find nothing to hold on to in the modern world and return to their traditions, because that is the only point of reference that they still have.

Matt: Do you believe that your work has an influence on people's psychology?

Mandémory: I only make suggestions. My work may start debates or it might not. But it does not leave anyone unaffected.

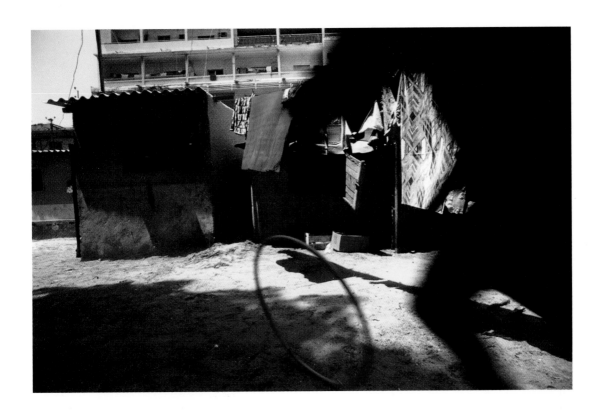

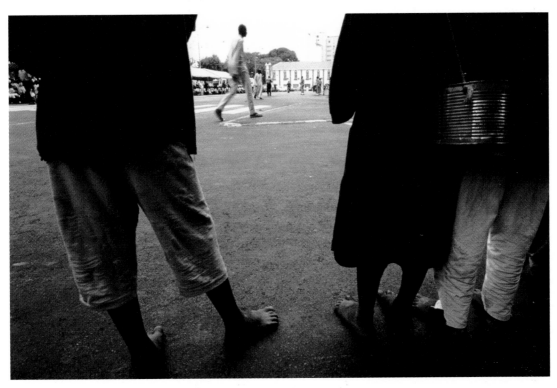

Boubacar Touré Mandémory, 2000

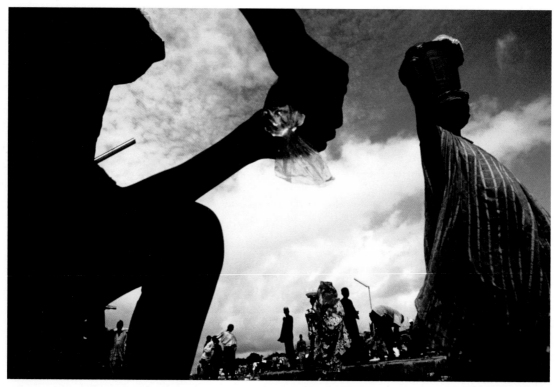

Boubacar Touré Mandémory, 2000

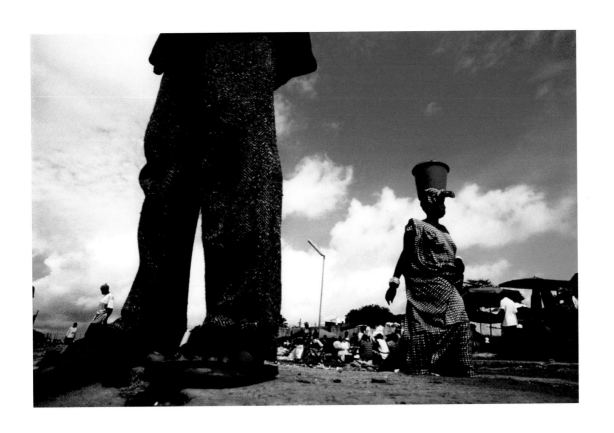

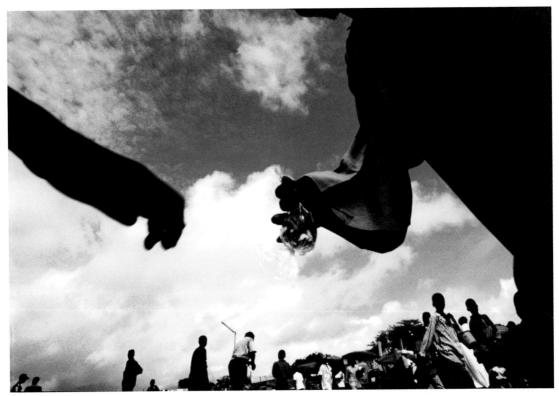

Boubacar Touré Mandémory, 2000

You can't lock up the djinns"

The Senegalese artist Bouna Medoune Seye talks about illuminated insanity, the political impact of the rappers of Dakar and the nonsense of subsidised Biennials in Africa. A conversation with Gerald Matt and Thomas Mießgang, 2001

Gerald Matt: Monsieur Seye, you are a photographer and a film producer. Among your most impressive works are "Zone Rap", a documentation on Senegalese Hip-Hop, and the photographic cycle, "Les trottoirs de Dakar" ("The Sidewalks of Dakar"). Can you tell us how this work came about, and how long it took you to complete it?

Bouna Medoune Seye: I now reside in Paris. However, I was born in Dakar and have also lived there for a long time. With us in West Africa, families have the option of leaving mad relatives outside to live in freedom. They have the alternative to either undergo a traditional or a modern form of therapy–but they are not locked up. I wanted to make this photographic cycle above all, because I have a feeling that I am like these people, footloose and fancy-free. Before the book "Les trottoirs de Dakar" was published, I had spent ten years working with the mad people who roam the streets of the city. I worked with them and I lived with them.

Thomas Mießgang: Are there many of these *"fous"* in Dakar?

Seye: Yes, very many. Generally, a great liberality prevails towards these mad people in Dakar, yes, even in all of Senegal. The fact that they are not hospitalised is for them almost like a kind of therapy. They can move about freely in the streets, feeding from rubbish bins.

Matt: Does the permissive attitude towards these mad people have anything to do with the strength of the family units in Senegal? Or is it simply that the people are too poor to afford a proper therapy for their relatives?

Seye: No, no, this has nothing to do with poverty at all. The mad people were always free in this country. Usually they get group therapy and, of course, there are also hospitals in Dakar that specialise in treating them. But many of these people simply prefer to remain in the streets, and their families accept that.

Mießgang: And how does the society react?

Seye: Society doesn't discriminate against the mad people either. Do you know, for us the *"fous"* are not merely mentally benighted, they are also illuminates. The mad person remains an individual like everybody else; with the only difference that he or she, as we say, is possessed. Sometimes we also express it in this way: the mad person has too much spirit and his or her consciousness is not human. If the spirit of a person lives with the djinns, then one must also accept that the djinns are free. One cannot lock them up.

Matt: Do the mad people come from certain environments or from all areas of the population?

Seye: They come from all ethnic groups and from all social classes. In former times a kind of therapy existed for the violent ones. They were tied up from morning till night and that made them calmer and less aggressive. There are mad people from very large and affluent families; but they are not locked up, because one simply doesn't want to restrict the djinns's freedom of movement.

Mießgang: Were the people you worked with just total strangers that you approached in the streets?

Seye: Often it was like that, and in the course of our work together we became better acquainted with each other. But it is not easy to establish contact with these people. They are usually very reserved and do not like to speak with people. It took me ten years to get to know them really well. I will never be done with this work, because I am actually quite mad myself, but then again not mad enough to want to become like these homeless people. When I'd already been working on this project for some five years, my family suddenly panicked. They said, "You will end up like these mad people some day".

Matt: Are there also people who were virtually driven to madness by their ever deteriorating living conditions?

Seye: Yes, there is such a thing as madness brought on by economic duress. Usually they are people, who moved from the country to Dakar on account of their financial problems. Then they live here and no longer wish to return.

Matt: How did the public in Senegal react to "Les trottoirs de Dakar"?

Seye: Well, the mayor, for example, said to me: "Now you're exaggerating." And I replied: "Was it I who brought the mad people to Dakar?" There are people, you know, who do not show much sympathy for art, or are even downright aggressive towards it. But that is all part of the game, even part of its intention. One needs to force people to take a look at the things they see every day, but which they do not wish to see.

Mießgang: Are the family structures we talked about earlier still a concern in Africa, or is globalisation and neo-absolutism of the post-independence era slowly eroding them?

Seye: I believe one would need to look at Senegal and the other African countries separately in this regard. Here, the families are not being destroyed. It's all the same, whether you are rich or poor. Family members do not leave each other in the rut. Individualisation has its limits as far as we are concerned. Normally the people always remain within the context of their families and their village communities. If they come into the city, they only do so, because things have come to a head. During the dry seasons of the Sahel it would be pointless for a Senegalese peasant farmer to remain in the country. There is often no rain, and agriculture is then no longer possible. That is why Dakar continues to grow and become ever more densely populated.

Matt: How did you begin working as a photographer and what was your family's attitude to this profession?

Seye: My parents never understood it. I started out by studying law, but soon gave it up and devoted myself entirely to photography. I told my parents that this was my destiny and at some point, they finally accepted it. In my own self-estimation, I was always a photographer ever since my childhood. When I was still quite small, I had sought out all the photography studios in the neighbourhood and took much delight in the fact that my mother quite happily and frequently had herself photographed. I also played with a kind of puppet theatre with figures I had cut out of cardboard. That was my first access to an artistic form of expression. It is not easy being an artist here in Dakar because the politicians generally have no awareness of how creative people can contribute to the nation's economic prosperity. We are a country where peanuts are cultivated, but in truth art contributes substantially more to the gross national product. In Senegal, however, artists are pushed right out to the edges of society, particularly if they originate from less affluent families. There have been people, who were driven to suicide by this situation. On the one hand, they were obstructed in practising their art, while on the other, they were regarded as sluggards by their families.

Mießgang: Can you tell us how photography in Senegal has developed in the 20th century?

Seye: In actual fact, everything started with Mama Casset. This man was the first major photographer in Senegal. Before him, there was Meissa Gueye, who was already taking pictures in the early years of the previous century. Mama was born in 1908, and he took up his photographic apprenticeship in 1920. He was an NCO and a photographer in the French army and took pictures during colonial times throughout Africa. I even met and became personally acquainted with Mama Casset and quite consciously followed the tradition that he had created. In this way, I wanted to expressly point out that Senegal has a history of photography, which dates back at least a hundred years. In the past I would often tell acquaintances, "I have a Senegalese photograph that is 80 years old", but nobody would believe me.

Matt: Monsieur Seye, you have not only taken photographs, but have also made films and videos...

Seye: Yes, I wanted to watch my photographs starting to walk. I wanted to see the continuity of movement, and to observe how the negatives came in motion. I had returned from France to Dakar in 1986 and was given the opportunity by one particular producer to take my first steps in the field of cinema.

Mießgang: We were particularly impressed by your documentary work, "Zone Rap", in which a Senegalese subculture that is hardly known here at all introduces itself.

Seye: Now, they always told me: don't ever allow the rappers to get a word in, because they have nothing to say anyway. But that is not true at all. I have known the Rap movement for the past 15 years. I am a part of it, myself. I know most of the groups, no, I actually know them all. And I shot the film, because I wanted to help them find their own language and a means of expressing it. They should be able to say what they think. My camera was only a witness of their expressive intention. The Hip-Hop people explain very well what is awry in Senegal and also on the Ivory Coast. They point a finger at the errors of the public administration, they speak of the young people who are sacrificed by the politicians for their own personal aims, of those politicians who led our country into misery. To give you just one example: if a government minister embezzles cash that was intended for inoculations against polio to buy a Mercedes for himself, then three or four thousand young people will end up in the streets as cripples. The rappers state it clearly: there must be an end to the suppression of public funds, the people in government must stop thinking about themselves only, they must find a way to think of the common weal.

Matt: Your film is made very cleverly. There are scenes, which are swayed by a strong groove. Then again, one only hears the voices of the rappers, inventing a rhythm of their own without any drum accompaniment.

Seye: I don't know. I have a quite elementary style of guiding the camera. But I do not leave anything to chance in my art. If I cannot master a subject, then I won't touch it. For me it would be dangerous to show a work, which I could not explain. It would be dangerous for my own mind.

Mießgang: Is it true that the rappers in Dakar are a kind of Voice of Youth, a kind of oral CNN for the many illiterates that live in the city?

Seye: The rappers, in any case, are no informers for the authorities, they inform the people. In Senegal the educational system, which was called the *"système claque"*, was a failure. This system involved instructing the pupils by means of televised courses. What they learned in this way was only to repeat things but they still could not read. Now the rappers are helping them to be informed about social and political events in our country. This they do by stating in a very straightforward way just what is what. The politicians do not like them, that is quite clear, because the rappers come out with the things that they would rather conceal.

Matt: Monsieur Seye, in francophone Africa, the arts are strongly linked with French institutions. Is this a helpful link, or does it just build up a renewed relationship of dependency?

Seye: I do not understand the concept of "assistance" in the cultural area at all. These cultural centres to some degree represent a real danger for the artists. If they take a big name artist under contract, then in the long run it's the cultural centre that becomes the star and not the artist. All of these biennials, which were created in Africa–what was the outcome for the artists themselves? Next to nothing. And in most cases, they are also very poorly organised. If the artists dash off to the biennials in Dakar or Bamako and buzz about with their invitation cards from one idiotic reception at a gallery to the next, then that doesn't do anything for anybody. At best the organisers themselves stand to gain: France doles out some cash, the European Union pays for it, but only those people are promoted who had been favoured from the very outset.

Mießgang: Is there an alternative to these conditions, in the shape of some idea of an all-African form of art or do the artists in each country work along by and for themselves?

Seye: I believe that art is in any case a personal effort to begin with. The pan-African vision was primarily a political and economic concept and only at a secondary level did it also have something to do with culture. I respect the creators of pan-Africanism, but I am convinced that if one had placed artists at the head of this movement, then we would not be in the situation we are in today.

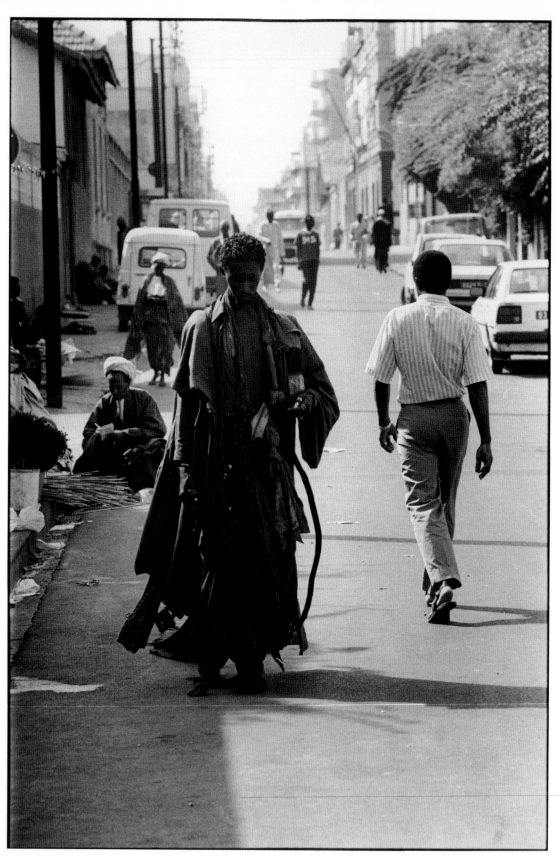

Bouna Medoune Seye, Les trottoirs de Dakar

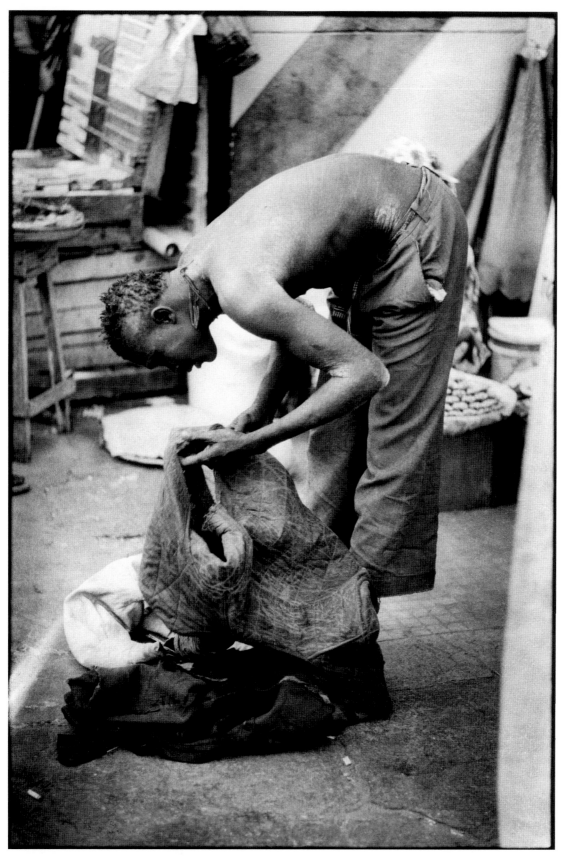

Bouna Medoune Seye, Les trottoirs de Dakar

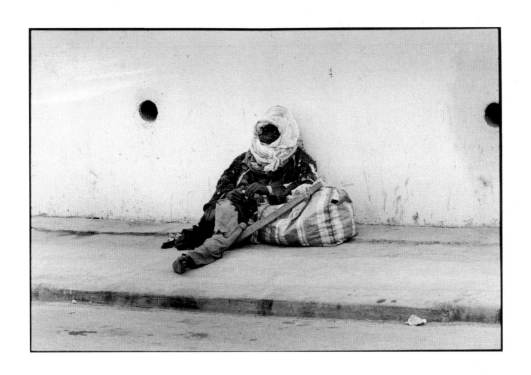

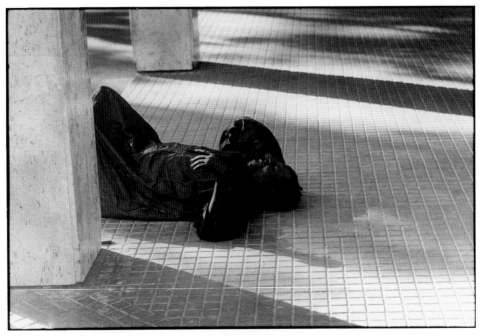

Bouna Medoune Seye, Les trottoirs de Dakar

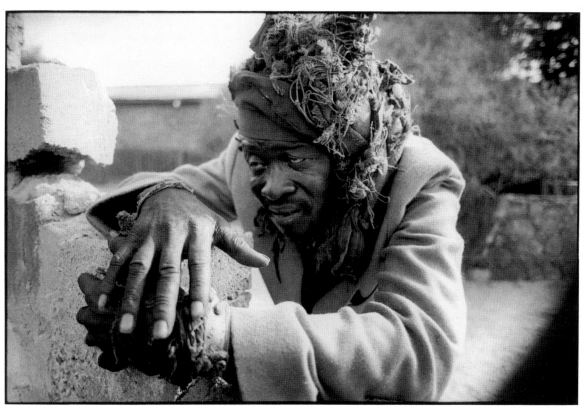

Bouna Medoune Seye, Les trottoirs de Dakar

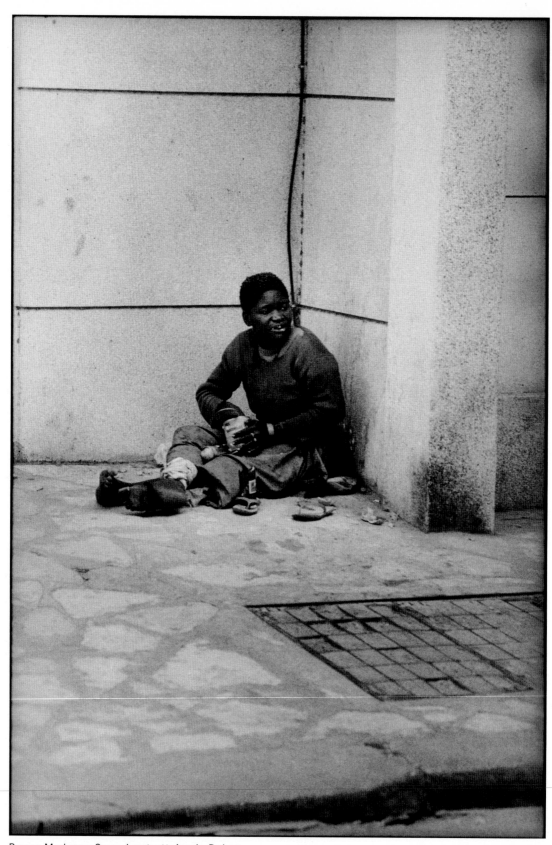

Bouna Medoune Seye, Les trottoirs de Dakar

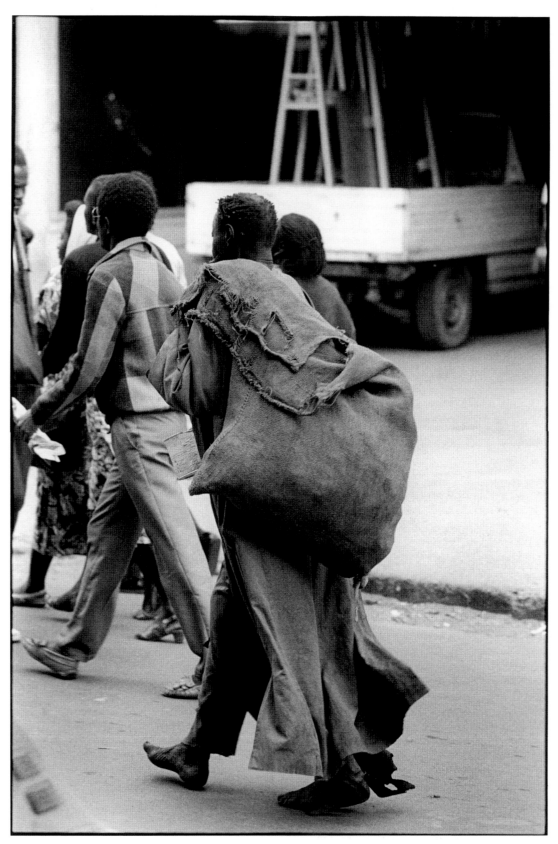

Bouna Medoune Seye, Les trottoirs de Dakar

The movement of life

Malick Sidibé about his concept of realism and the crisis of young African photography. A conversation with Simon Njami, 2001

Malick Sidibé disproves the commonly held view in the West that African photography is confined to portrait and studio work. His leitmotif is "independence" and his photographs capture the moments of happiness and freedom following the independence of Africa. He does not simply express the *joie de vivre* and carefree attitude of this time, known as *les années twist*. His work is a living testimony to an epoch in which Africans believed that everything was possible.

Sidibé was born in Soloba (Mali) in 1936. Like many of his generation, his encounter with photography came about through a series of coincidences.

Seydou Keïta, another internationally renowned photographer 13 years his senior, came into contact with photography through the suggestion of a neighbour, teacher and photographer Mountaga Dembelé, who likes to style himself as the "father" of photography in Mali. Keïta opened his own studio in 1949. Abderamane Sakaly, the dandy and star of the 1960s, when studio photography reached its acme, was a driver and seller of fabrics and jewels before he discovered photography in the 1950s thanks to his acquaintanceship with Claude Rollin, a young French artist recently arrived in Bamako, and the untiring instruction of Nabi Doumbia, another pioneer of photography in Mali. Sakaly opened his own studio in 1957.

In Malick Sidibé's case, his skill at drawing led him to photography. His father was a farmer, and he was the only child in his family to go to school. One of his teachers discovered his talent for drawing and advised him to enrol at the Maison des Artisans Soudanais. After graduation he sought a job where he could utilise his skills and was hired in 1955 by Gérard Guillat, who ran a photo studio. Here he was a jack-of-all-trades, which also gave him the opportunity to learn about photography. He found out how to use a Kodak Brownie and completed his first independent reportage in 1957. Further reportages followed, but his main interest was in young people and their gatherings and parties. He turned down Guillat's offer for him to take over the studio and in 1962 opened his own studio in Bagadadji instead, where he worked in particular in the formats 6x6 and 24x36. With the advent of colour photography and professional laboratories, he concentrated on repairing cameras, but the passion remained and it wasn't long before he regained prominence as a photographer. In 1988, he became president of the GNPPM, the photographers' union in Mali.

Sidibé's studio is without a doubt one of the most picturesque in Bamako. Dozens of cameras can be seen on the shelves, as if they were in a museum, and time appears to have stood still; a customer wanders in occasionally for passport photos. Our discussion took place in the gentle shade of the studio with the noises of the street audible through the open door. We looked at photos in old portfolios; this was a real piece of luck, since few photographers feel such a close attachment to the pictures that effectively mapped their careers. With a smile, Sidibé talked about each of the faces he had photographed. He knew them all. They were local children who had now grown up. Looking at him, it occurred to me that the secret of this bygone era was the evident intimacy and familiarity that now appears to have been lost forever.

Simon Njami: There were photographers before you–Mountaga Dembelé, for example–but photography in Bamako really blossomed in the 1960s. What was it like then?

Malick Sidibé: It was the time of independence. Studios had plenty of work and there were always customers. Because they often came after work, the studios remained open until late into the night, and I employed a boy to make a note of the orders. We were able to work uninterruptedly for hours at a time. Seydou Keïta stopped doing studio photography in 1962 to work for the Sûreté. His studio was successful but at this time Sakaly was the star; he worked at banquets, hotel soirées and receptions and photographed well-known personalities. I was one of the younger generation to take over portraits, baptisms and weddings. But I preferred more intimate occasions and liked to photograph young people having a good time. I found birthdays and parties among friends more interesting than studio work. I was always attracted by movement and liked the spirit of these young peo-

ple who had discovered European music. They dressed well and partied all night. This is what I tried to capture in my pictures.

Njami: How did your passion for photography come about? Photographers of your generation say that they "learnt by doing". What about you?

Sidibé: I came to photography through a series of coincidences. My teacher at school thought that I had a talent for drawing and advised me to enrol at the Maison des Artisans Soudanais, a vocational college. On graduation I got a job in a photo studio with Gérard Guillat, a Frenchman who worked for the colonial administration. I was meant to paint the decorations but became a jack-of-all-trades and also took care of the accounts. Gérard gradually allowed me to work in the laboratory and finally to take photos of my own–although only of African customers, since Europeans would not have wanted to be photographed by an African. I got on well with Gérard, but Europeans are sometimes a little strange. When he left for New Caledonia because of a disappointment in love, he asked me if I wanted to take over the studio. At the time, I was unable to accept. In 1962, I opened my own studio, where I still work today.

Njami: Together with Seydou Keïta you are now one of the most famous African photographers in the world. How do you feel about this celebrity?

Sidibé: We were already well known in Bamako but in the 1990s our work gradually became known internationally as well. The recognition for my work in the 1960s and 1970s was very encouraging, because in those days we could only think from one day to the next. We worked intuitively without too much thought. If photography had been as well known then as it is now, through events like the Biennial in Bamako, we might not have worked in that way. It was only through the various exhibitions to which we were invited that we noticed, while still hardly taking it in, that our work was appreciated. Since the 1960s, and in some cases since the 1940s, we have simply concentrated on recording our own African reality without giving a thought to the possibility of the photos being seen outside Africa. As not everyone can read and write–in the 1960s it was even worse–pictures are the only generally accessible form of communication in Africa. Without them we cannot understand the world around us. In Africa, and elsewhere as well, pictures offer instant communication because their message is direct.

Njami: During the golden years of studio photography you liked to go out a lot–to private parties, to the banks of the Niger, where young people went swimming on Sundays. Why?

Sidibé: I have always liked young people and felt good in their company. I don't like posed pictures; I've always felt the need to bring some life into my photos. Even in my studio photos, I was interested in movement. I was not happy when my subjects just sat there. I encouraged them to take a more casual pose so that their children and grandchildren would have a vivid memory of them and could form an idea of what they were like. That's what attracted me to young people and their parties as well. I really enjoyed watching them dance; the liveliness of their movements fascinated me. That's probably why I've only ever photographed people. Of course, I didn't know about anything else at the time and there wasn't a demand for it anyway. But even if I could have photographed something else, I think I would still have taken the same pictures, because lifeless objects have never attracted me.

Njami: You seem to be very attached to your time and you intimate that things today are different. What do you think of modern young African photographers?

Sidibé: This generation appears to be very attracted by Europe–a mistake in my opinion. We cannot shift overnight from one reality to another. We are a relatively young continent and have lots to discover about ourselves. We should get to know ourselves better before trying out new experiences. I am constantly telling young photographers that we must not stop capturing our own reality; we cannot yet allow ourselves to dabble in the kind of pictures that are found in the West. If you come across it by chance, that's OK. But we are not yet mature

enough for psychologising photography, for example. We live in a very concrete reality. We must investigate the wealth we can offer to future generations. This uncultivated field needs to be discovered and captured for the future. So far, not many young African photographers have impressed me. I know a few from Burkina, Côte d'Ivoire; I don't know any Senegalese photographers and I'm still looking in Mali. But I haven't given up hope. I am sure that I'll find some. If we accept our own experience as the starting point, I am sure that talented young photographers will emerge. Young Africans need to look into themselves for their pictures. A while ago I was talking with some Europeans in Nantes who believed that they should do whatever they felt like. They tried to convince me that it would be in the spirit of history if the young generation were to try out new things, but I don't agree. They don't have the right to do just what they please. They have an obligation to Africa and should take pictures that establish a link with our continent. It's like a search. You don't need to search until you have found the right way to communicate with your own people. This is the task of young photographers.

Njami: But these Europeans have a point. You can't ask young people to do what you did forty years ago.

Sidibé: That's right. But I'm not asking them to do what we did. Life goes on, and it is normal that they should evolve. But photography in Africa will have a future only if the young people listen to us and understand how to make use of the opportunities that we didn't have. As I have already said, we were left to our own devices and no-one was interested in our work apart from the customers. Photographers today have many more opportunities. They have access to information that was not available to us and they should use it intelligently. There are themes such as landscapes that were not very popular in my day but could well work today. Young people have much more freedom than we had and can choose from a wider range of subjects. They should take up where we left off. That is the spirit of history, something that is very important to me.

Njami: What is missing? They have the means, favourable circumstances, material and subjects. What else is there?

Sidibé: There is passion. I don't think that the young generation are really passionate about their work. I think we were more so. We loved our work. If a customer was happy with a picture, we could share this happiness. I liked to mix with young people because I felt comfortable there, and I enjoyed catching their vitality and *joie de vivre*. Today, on the other hand, I often have the feeling that photographers think only of money. We were professionals and also had to earn our living, of course. But there is no passion today, not even amongst children. They photograph what they are asked to photograph, but the lifeblood doesn't flow. I get the impression that they would photograph anything as long as they were paid for it. But that might also have something to do with a new mentality. In our day, we lived in a community and were always together. The family was of great significance. Today, by contrast, the world has become much more individual. Music is a good example: at concerts the audience sit there passively, listen and applaud. But they should be taking part. In our days, we barely noticed the musicians; we listened to the music and danced until we were dripping with sweat. It was inconceivable not to have everyone dancing together at a concert. Today the "star" is separated from the audience. This is something I cannot understand.

Njami: You have been travelling around the world for decades and have learnt a lot about African photography. Can you tell us about what you have seen?

Sidibé: I have the impression that the same thing has happened in Europe as in Africa. I remember pictures from Europe in the 1950s and 1960s whose quality moved me very much. You could sense the love of the work and of photography. When I see some of the reportages today, I have the feeling that the photographers take themselves more seriously than their subjects. They don't take photos, but speak about themselves. I have talked with European photographers of my generation and they agreed with me. I have seen lots of pictures in Europe that didn't interest me in the slightest. It's like contemporary art: I don't understand what the people are trying to say. The older pictures were better. I'm very disappointed. I've lost the Europe I knew from earlier days.

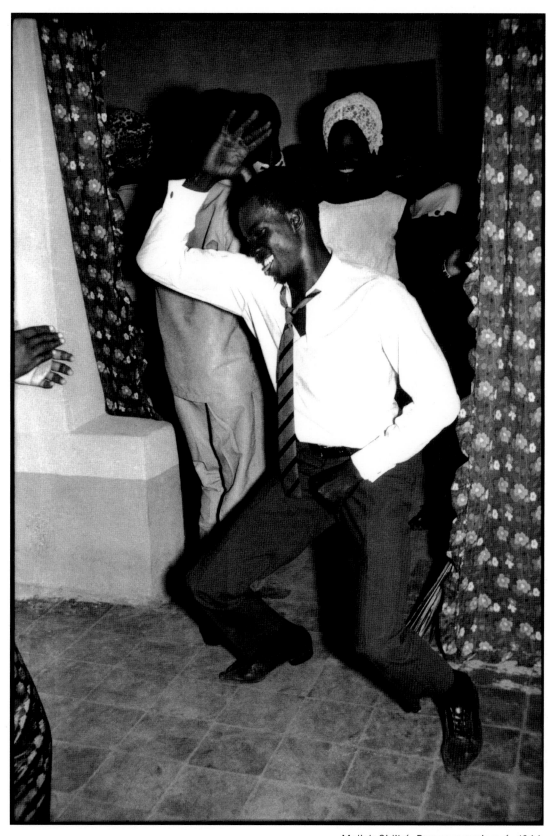

Malick Sidibé, Danseur meringué, 1964

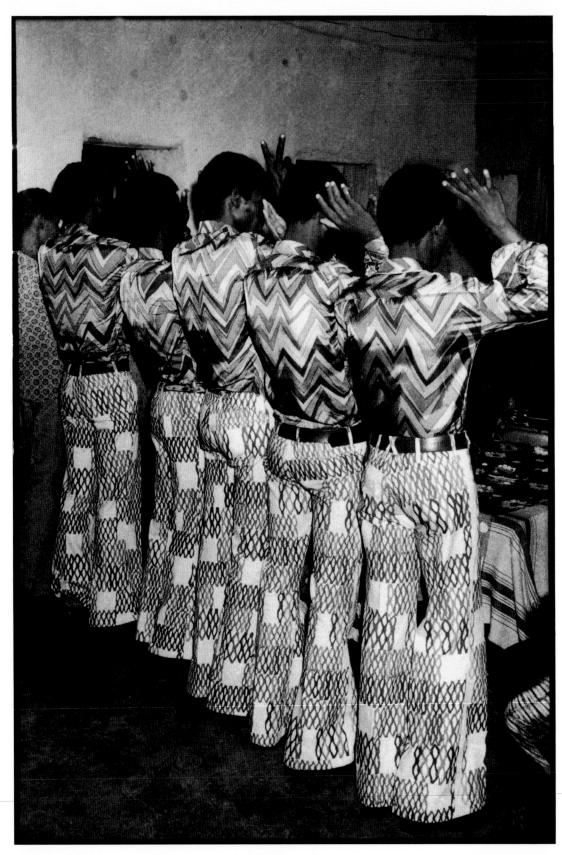

Malick Sidibé, Les très bons amis dans la même tenue, 1972

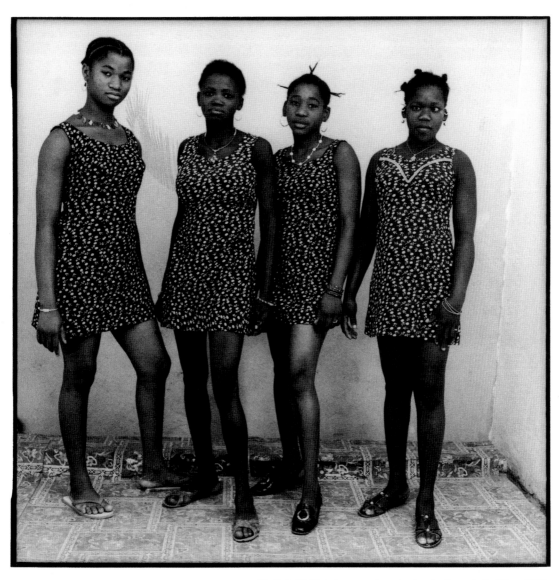

Malick Sidibé, Les quatres amies le jour de la fête, 1973

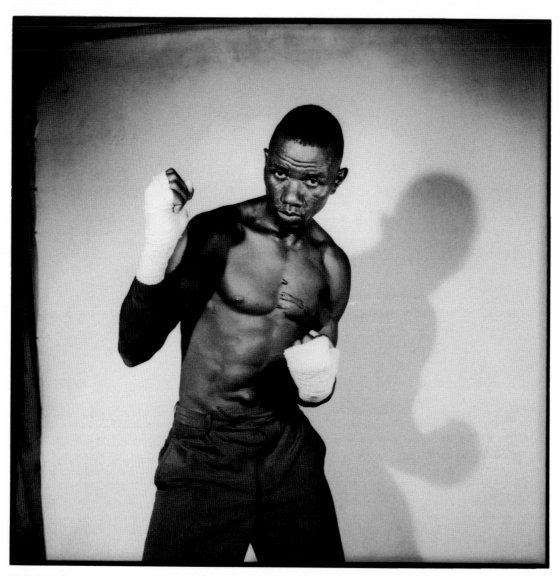

Malick Sidibé, Boxeur, 1966

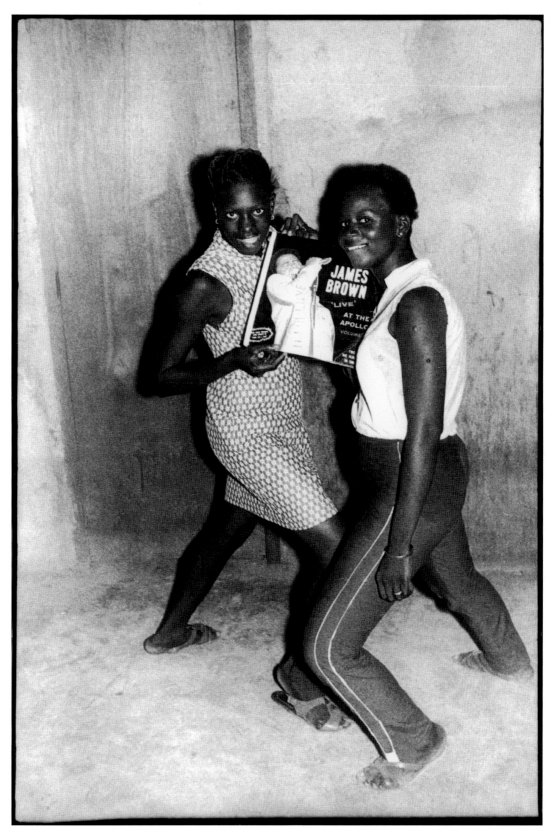

Malick Sidibé, Fans de James Brown, 1973

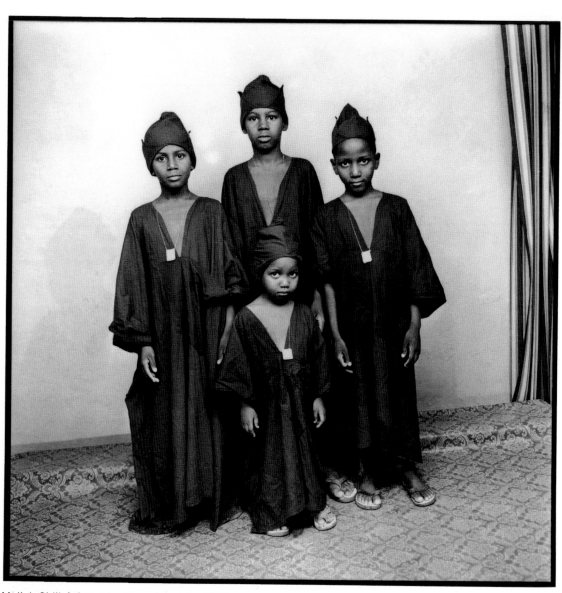

Malick Sidibé, Les nouveaux circoncis, 1983

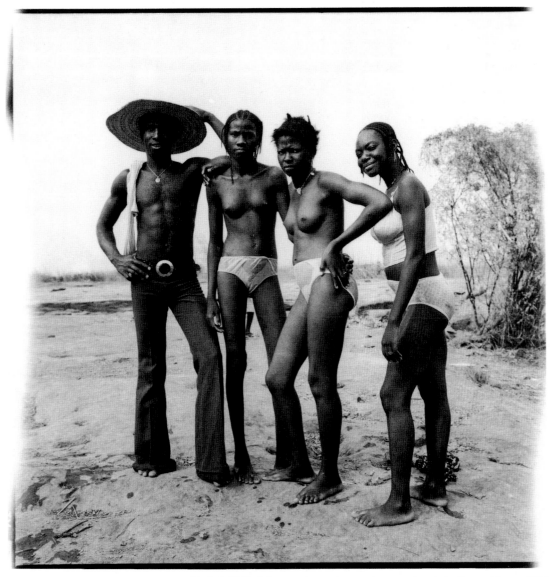

Malick Sidibé, Les amis sur les rochers au bord du fleuve Niger, 1976

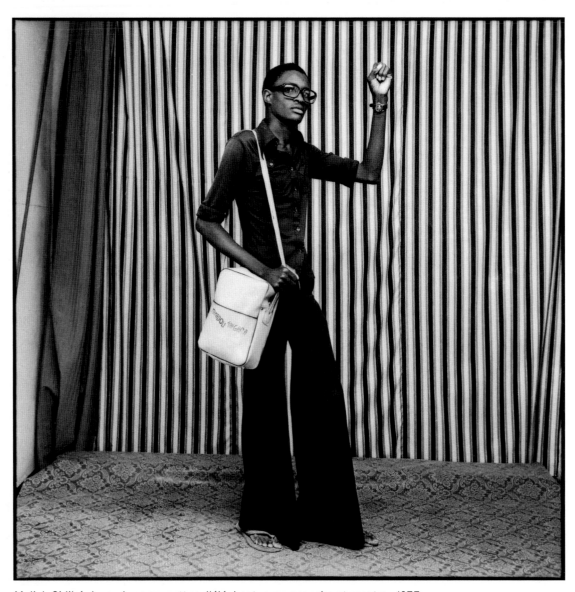

Malick Sidibé, Jeune homme, pattes d'éléphant, avec sacoche et montre, 1977

Artist's biographies

Philip Kwame Apagya
Born 1958 in Sekondi, Ghana
Lives and works in Shama, Ghana

Exhibitions (selection):

2002
Philip Kwame Apagya, Alliance Francaise, Bahia

2001
Berlin Portraits by Philip Kwame Apagya, Ghana National Museum, Accra
The Leopold Godowsky Jr. Color photography award winners 2000, Boston University, Boston
Flash Afrique, Kunsthalle Wien, Vienna

2000
Porträt Afrika, Haus der Kulturen der Welt, Berlin
Philip Kwame Apagya - Portraits, Gallery Forma Libera, Torino
Expressions africaines, Maison International, Rennes
Studio Apagya, Centre national de la cinématographie, Cannes
African Photographers, 51 art gallery - Roger Smulewizc, Antwerp
Africainside, Fries Museum, Noorderlicht-Festival, Netherlands

1999
Africa by Africa, Barbican Art Gallery, London

1998
Retour de Bamako, Galleries FNAC, Paris; FNAC, Barcelona
Festival des trois continents, Nantes
3émes Rencontres de la photographie africaine, Bamako, Mali
Snap me one! City Museum, Munich

1997
The Face of Africa, press house of Geo magazine, Hamburg

Bibliography (selection):

Tobias Wendl /Heike Behrend (ed.), Snap me one! Studiofotografen in Afrika, exhib. cat., Munich, London, New York 1998, p. 52-63
Pascal Martin Saint Léon (ed.), Anthologie de la photographie africaine, Paris 1998, p. 108-109, 111, 114, 117
Africainside, exhib. cat., Fries Museum, Groningen 2000, p. 93-96
Porträt Afrika. Photographische Positionen eines Jahrhunderts, exhib. cat., Haus der Kulturen der Welt, Berlin 2000, p. 58-67

Dorris Haron Kasco
Born 1966 in Daloa, Côte d'Ivoire
Lives and works in Abidjan and Paris

Exhibitions (selection)

2001
Flash Afrique, Kunsthalle Wien, Vienna

2000
Africainside, Fries Museum, Noorderlicht-Festival, Netherlands
Porträt Afrika, Haus der Kulturen der Welt, Berlin

1998
L'Afrique par elle même, Maison Européenne de la photographie, Paris; Museum of Arts, Washington, Washington DC, a.o.

1990-1993
Les fous d'Abidjan, Lorient; Lisbon; Coimbra, a.o.

Bibliography (selection):

Les fous d'Abidjan, Revue Noire (ed.), Paris 1996
Anthologie de la Photographie Africaine et de l'Océan Indien, Revue Noire (ed.), Paris 1998, p. 286-87
Porträt Afrika, exhib. cat., Haus der Kulturen der Welt, Berlin 1999, p. 79-85
Africainside, exhib. cat., Fries Museum, Groningen 2000, p. 61-65

Seydou Keïta
Born 1921 in Bamako, Mali
Lives and works in Bamako

Exhibitions (selection):

2001
Gallerie Nazionale d'Arte Moderna, Rome
The Short Century, Museum Villa Stuck, Munich
Flash Afrique, Kunsthalle Wien, Vienna

2000
The Museum of Contemporary Photography, Chicago
Le Monde dans la Tête, Musée d'Art Moderne de la Ville de Paris, Paris
Porträt Afrika, Haus der Kulturen der Welt, Berlin

1999
Kunstwelten im Dialog, Museum Ludwig, Cologne
Saint Louis Museum of Art, Saint Louis

1998
Biennale São Paulo, São Paulo
2nd Moscow Photo Biennial, Moscow
Fundacio Joan Miro, Barcelona
Institut Français D'Athènes, Athens

1997
Amours, Fondation Cartier pour l'Art Contemporain, Paris
Gagosian Gallery, New York
Pinacoteca do Estado de São Paulo, São Paulo
Museum of Modern Art, San Francisco

1996
African photographers, Guggenheim Museum, New York
Double Vie - Double Vue, Paris
Africaines, 1er Festival de la photographie des 3 continents, Nantes
Minneapolis Institute of Art, Minneapolis
National Museum for African Art, Smithsonian Institute, Washington D.C.

1995
Serpentine Gallery, London
Counter Cultures, Nederlands Foto Instituut, Rotterdam
Self evident, Ikon Gallery, Birmingham
Fruit Market Gallery, Edinburgh
Helsingin Taidehalli Helsingfors Konsthall, Helsinki

1994
Seydou Keïta. Portraits de 1949 à 1964, Fondation Cartier pour l'Art Contemporain, Paris
Premières Rencontres Photographiques de Bamako, Mali
Ginza art's space, Shisheido, Tokyo

1993
Troisièmes Rencontres Photographiques de Normandie, Rouen

1991
Africa Explores, The Center for African Arts, New York

Bibliography (selection)

Seydou Keïta - 1949 à 1962, exhib. cat., Fondation Cartier pour l'Art Contemporain, Paris, 1994
African Arts, volume XXVIII, number 4, Port-Folio, 1995
André Magnin (ed.), Seydou Keïta - Livre monographique, 1997
Robert Storr, Bamako-Full Dress Parade: Seydou Keïta, in: Parkett, No. 44, 1997, p. 25–29
Manthia Diawara, Talk of the Town, in: Artforum, February 1998, p. 64–71

Boubacar Touré Mandémory

Born 1956 in Dakar, Senegal
Lives and works in Dakar

Exhibitions (selection)

2001
Aubenades de la Photo, Aubenades
Festival de la Photographie, Arles
Reportages Sénégal, Niger, Bénin, Mali
Rencontres de la Photographie Africaine, Bamako
Flash Afrique, Kunsthalle Wien, Vienna

2000
Le mois de la photo, Dakar

1998
Galerie du Théatre, Gap

1997
Festival des Trois Continents, Nantes

1996
Recontres du Cinéma du Réel à Beaubourg, Centre Georges Pompidou, Paris

1995
La photographie africaine, Fnac, Paris
Le mois de la photo, Dakar
Couleur - Couleurs, Art Cadres et Château de Servièrs, Marseille
Regards croisés, Saint-Louis

1994
Saint-Louis, Dakar
Dakar, Musée d'Art africain, Bamako

1992
Photographie contemporaine sénégalaise, Dakar

1986
Musée naval de Gorée

Bouna Medoune Seye

Born 1956 in Dakar
Lives and works in Dakar

Exhibitions (selection)

2001
Flash Afrique, Kunsthalle Wien, Vienna

2000
Atelier MC2A, Bordeaux

1998
La Cour de Joe, Maison Européenne de la Photographie, Paris
L'Afrique par elle-même, Pinacoteca do Estado, São Paulo, Smithsonian Insitute, Washington, a.o.

1997
Suites africaines, Couvent des Cordeliers, Paris
Les trottoirs de Dakar, Evocos, Lisbonne

1996
Les trottoirs de Dakar, Galerie 39, Dakar

1995
Les trottoirs de Dakar, Centre d'art contemporain de Genève

1994
Rencontres Internationales de la Photographie, Bamako

1992
Centre Wallonie-Bruxelles á Paris

Bibliography (selection)

Bouna Medoune Seye, Les trottoirs de Dakar, Paris 1994
Revue Noire, special issue Dakar, 1991
Pascal Martin Saint Léon (ed.), Anthologie de la photographie africaine, Paris 1998, p. 310–311

Malick Sidibé

Born 1936 in Soloba, Mali
Lives and works in Bamako, Mali

Exhibitions (selection)

2001
Flash Afrique, Kunsthalle Wien, Vienna

2000
Porträt Afrika, Haus der Kulturen der Welt, Berlin
Malick Sidibé, Centre d'Art Contemporain, Geneva
Malick Sidibé, Stedelijk Museum, Amsterdam
Malick Sidibé, Galleria Nazionale d'Arte Moderna, Rome

1999
Malick Sidibé. The clubs of Bamako, Deitch Projects, New York
Malick Sidibé, Australian Center for Photography, Sydney
Malick Sidibé, Museum of Contemporary Art of Chicago, Chicago
Istanbul Biennial, Istanbul

1998
Malick Sidibé, Institut Français d'Athènes, Athens

1997
Photographie 1962–1976. Clubs und Twist und Chats Sauvages, I.F.A., Stuttgart

1996
In/sight: African Photographers, 1940 to the Present, Solomon R. Guggenheim Museum, New York

1995
Malick Sidibé, Fondation Cartier pour l'Art Contemporain, Paris
Seydou Keïta - Malick Sidibé, Fruit Market Gallery, Edinburgh

Bibliography (selection)

André Magnin, Malick Sidibé, Zürich, Berlin, New York 1998
Pascal Martin Saint Léon (ed.), Anthologie de la photographie africaine, Paris 1998, S. 182–185, 294–295
Porträt Afrika. Photographische Positionen eines Jahrhunderts, exh. cat., Berlin 2000, S. 29–37
In/sight: African Photographers, 1940 to the Present, exh. cat., New York 1996, S. 90–93

Colophon

Editor: Gerald Matt, Thomas Mießgang, Kunsthalle Wien

Editors: Thomas Mießgang, Barbara Schröder
Proof Reading: Nita Tandon

Translations: Tom Appleton (Kasco, Mandémory, Seye, Sy),
Nick Somers (Apagya, Mießgang, Kouoh, Njami, Sidibé)

Graphic design and printing:
Steidl, Göttingen

© for the texts by the authors, for the images see photo credits
© for text Kapuściński: Penguin UK, London
© KUNSTHALLE wien 2001
ISBN 3-85247-032-3
© Steidl, Göttingen 2002
ISBN 3-88243-638-7

Kunsthalle Wien, an institution of the city of Vienna for modern
and contemporary art, is supported by
Kulturabteilung MA7

Director: Gerald Matt
Managing director: Bettina Leidl
Head of Exhibitions: Sabine Folie

Thanks to
We kindly thank for the support
AFAA

Photo credits

© Boubacar Touré Mandémory, S. 87-89
© Bouna Medoune Seye, S. 29-30, S. 94-100
© Dorris Haron Kasco, S. 33, S. 64-70
© Gorée Institute, S. 42-43
© Mamadou Touré Béhan, Revue Noire, S. 36, S. 39
© Malick Sidibé; C.A.A.C. – The Pigozzi Collection,
 Geneva, S. 26, S. 104-112
© Olu Oguibe, S. 13
© Philip Kwame Apagya, S. 19, S. 55-61
© Seydou Keïta; C.A.A.C. – The Pigozzi Collection,
 Geneva, Cover, S. 22, S. 76-83